ISBN 978-0-265-99571-6
PIBN 10920681

(The Studio. Special number. 1917.)

EARLY ENGLISH
PORTRAIT
MINIATURES

IN THE COLLECTION OF
THE DUKE OF BUCCLEUCH

EDITED BY
CHARLES HOLME

TEXT BY
H. A. KENNEDY

MCMXVII
"THE STUDIO" LTD.

PREFATORY NOTE

AN article by Mr. T. Martin Wood on the Buccleuch Miniatures at the Victoria and Albert Museum appeared in the January 1917 issue of THE STUDIO. The collection, however, is of such unusual interest and importance, both artistically and historically, that, in order to deal with it at greater length, the Editor decided to devote a Special Number to the Early English examples, in which the collection is particularly rich.

The Editor and Author desire to express their grateful thanks to His Grace the Duke of Buccleuch for permitting the miniatures in his collection to be illustrated ; and to the Director of the Victoria and Albert Museum for sanction to reproduce prints from the official negatives.

The authorities consulted are acknowledged in the text, but the Author would like to take this opportunity of expressing his special indebtedness to Mr. R. C. Goulding's Catalogue of the Welbeck Abbey Miniatures, published by the Walpole Society as its Annual Volume for 1914-1915.

The notes on heraldry, where these occur, have been kindly furnished by Mr. A. Van de Put, of the Victoria and Albert Museum, and those on the wooden frames of some of the miniatures by Mr. H. Clifford-Smith, F.S.A. The Author's thanks are due to the above; to Mr. B. S. Long, now on active service, who has very kindly placed at the Author's disposal the results of his preliminary study of the Collection ; to Mr. J. D. Milner, Director of the National Portrait Gallery ; and to Mr. R. C. Goulding, Mr. Charles Scott, and other friends, for the valuable assistance given in the preparation of these notes.

A list of the miniatures by English artists, or by foreign artists working in England, at present on exhibition at the Victoria and Albert Museum will be found at the end of the number. Existing titles and attributions have so far as possible been retained ; and whenever a serious doubt arises as to the correctness of any particular title, a reference is given to some other portrait with which the miniature may be compared, or a note is inserted briefly explaining the difficulty. Practically all the authorities quoted may be consulted in the Library of the Victoria and Albert Museum.

ILLUSTRATIONS IN COLOURS

ILLUSTRATIONS IN MONOTONE

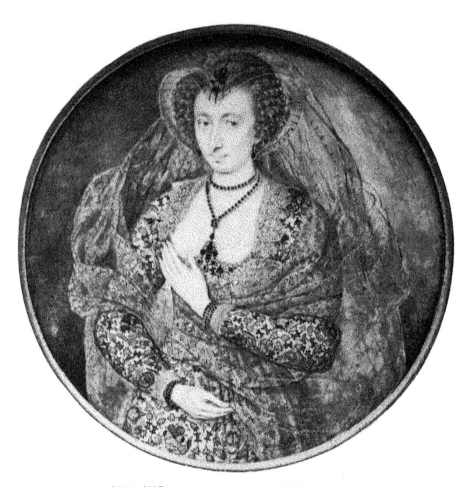

LUCY HARINGTON, COUNTESS OF BEDFORD
BY ISAAC OLIVER

PLATE I

NOTES ON SOME MINIATURES IN THE BUCCLEUCH COLLECTION BY ENGLISH ARTISTS OR BY FOREIGN ARTISTS WORKING IN ENGLAND

" In no branch of iconography is so much caution and scepticism required as in dealing with miniatures."—C. F. Bell in "Historical Portraits, 1600–1700."

FROM information courteously furnished by the Duke of Buccleuch, and published in the Introduction to the official handbook issued in connexion with the exhibition at the Victoria and Albert Museum, it appears that the formation of this splendid collection was principally due to Walter Francis, Fifth Duke of Buccleuch (d. 1884), who made numerous additions by purchase to the collection of upwards of one hundred and fifty miniatures, which he inherited from Elizabeth, Duchess of Buccleuch (d. 1827). Whether this not inconsiderable nucleus was wholly brought together by Her Grace, or in part inherited from her mother Mary, Duchess of Montagu (d. 1775), is uncertain. It was the latter who, with her husband, George Brudenell, Earl of Cardigan, created Duke of Montagu, purchased many of the best pictures at Montagu House; the former who started a collection of engravings, partly for the big "Granger" (now on loan to the Museum), and so may have been led to collect miniatures as well. A conjecture that the nucleus represented the acquisitions of more than one generation would not be, perhaps, unjustifiable, for in a footnote on p. 684 of the "Anecdotes of Painting" (Wornum edition, 1849), Dallaway states that the head of John, Duke of Montagu, when young and another of the Duke of Marlborough by Arlaud, which Horace Walpole says were in the possession of the Duchess of Montagu, had passed to the collection of the Duchess of Buccleuch; and the two enamels by Zincke, numbered o 18* and o 5, might very well be the two "enamelled pictures of her sisters, Sunderland and Bridgewater," bequeathed by Sarah, Duchess of Marlborough, to her daughter Mary, who was the mother of the Duchess of Montagu, mentioned by Walpole. One very conspicuous addition was made by the late Duke of Buccleuch (d. 1914), who purchased the miniature of Lord Abergavenny, described below, at the sale of the Earl of Westmoreland's collection.

Be its exact origin what it may, there can be no doubt as to the extra-

* Throughout these Notes the writer has used the numbers given in the catalogue of the collection compiled by Andrew MacKay, and privately printed for the late Duke of Buccleuch in 1896.

ordinary importance and interest of the collection alike on historical and æsthetic grounds. Besides numerous examples of the work of the great masters, it includes a considerable number by unknown artists of the sixteenth and seventeenth centuries, in oil as well as water-colour, which indicate how high was the general level of ability displayed in those periods. True it contains no works by the famous miniaturists of the later years of the eighteenth century, but apart from these it affords a complete and fascinating epitome of the history of this peculiarly English art.

THE miniatures by Hans Holbein have been so carefully described by Mr. C. F. Bell in the Catalogue of the Exhibition of Early English Portraiture held at the Burlington Fine Arts Club in 1909, that it is unnecessary in these notes to refer to more than two or three of them. First in importance is the well-known portrait of *George Nevill, Baron Abergavenny*, K.G. (AA 12), painted in water-colour on playing-card * (Plate II). With its exquisite modelling of the features, its subtle treatment of the flesh, and its accurate drawing of the details of costume, this limning is admittedly a masterpiece of the art of painting in little, to which are comparable only such works as the same artist's *Mrs. Pemberton* in the Pierpont Morgan, or the *Anne of Cleves* in the Salting Collection. No definite information is available as to the date at which it was executed. During the first period of his residence in England (1526–1528/9) Holbein was, as is well known, under the protection of Sir Thomas More, and enjoyed the patronage of many of the leading persons at the Court of Henry VIII, among whom Lord Abergavenny is certainly to be counted. For he was a constant companion of the King, and accompanied him to the meeting with Francis I on the Field of the Cloth of Gold. On the other hand, Holbein is said to have turned his attention to painting in miniature in the later years of his somewhat short career, and the first of the miniatures, scheduled on page 258 of the monograph on his works in the series, " Klassiker der Kunst," is dated 1533. In 1532 Holbein was with the Hansa merchants of the Steel-yard, and engaged upon the well-known series of portraits of German traders ; in June 1535 Lord Abergavenny died. The probable limits are therefore narrowed to the years 1533–1535. The title, "G: Abergaveny," written in gold on the blue background, differs from the inscriptions sometimes added by Holbein to his miniatures and paintings, by being in cursive instead of uncial letters, and must consequently be regarded as in all probability by a later hand. It may be of interest to add that at the sale of the Earl of Westmoreland's collection in 1892 the price realized for this miniature was £430 10s. In 1904 the *Mrs. Pemberton* above mentioned was sold for £2750.

* The frames decorated in black and gold containing this portrait, that of a *Gentleman Unknown* (AA 16), and *Horatio, Viscount Townshend* (?) (AA 13) date from the late sixteenth

Other noteworthy miniatures by Holbein in the collection are *Queen Catherine Howard** (c 4), *Queen Jane Seymour* (c 5), and the self-portrait of the artist in his forty-fifth year, signed and dated 1543 (G 4, Plate II). There is an exactly similar portrait in the Wallace Collection, but when the two works are seen together, the difference in treatment which at once becomes apparent is such as to make it difficult to believe that both are by the same hand. In neither of them are the features so exquisitely drawn as those of Lord Abergavenny in the miniature just described, but the clever painting of the flesh in the Buccleuch self-portrait compares very closely with that in the portrait of *Queen Catherine Howard* (c 4), which is generally accepted as by Holbein. Neither has any known history anterior to the eighteenth century. That in the Buccleuch Collection was formerly at Strawberry Hill, but Horace Walpole in his "Description of the Villa" (p. 422) merely mentions "Holbein, in a round, original by himself" without saying how he acquired it. At the back of the brass case enclosing the Wallace Collection portrait is engraved : " Hans Holbens given to Me by Lord Bolingbroke 1757"—the recipient being, it is suggested in the official catalogue of the Collection (p. 106), King George II. The rather larger portrait of Holbein, in oil, also dated 1543, but presenting the right instead of the left side of the face, and without the brush in the uplifted right hand (G 3), possesses the interest that it corresponds with an engraving made by Hollar in 1647, after a self-portrait in the Arundelian Collection. It may perhaps be a copy of the head dated 1543, "most sweet," the presence of which in that collection was noted by Richard Symonds, writing in the middle of the seventeenth century ("Anecdotes," p. 93).

The limning of *Margaret Wotton, Marchioness of Dorset* (c 1), the grandmother of Lady Jane Grey, is also said to be by Holbein, but in style (see Plate VII) is very unlike the other examples of his work in this collection. Indeed, the markedly flat treatment of the features and the complete absence of the master's characteristic touch in the rendering

or early seventeenth century. They may be of French or Italian origin, but the design with which they are decorated is in parts very similar to that on a set of painted roundels exhibited in the Museum (w 30-1902), which are Jacobean.

* The small oil-painting in the style of Clouet (c 23), inscribed "*Catherine Howard— King Henry VIII*," is not a portrait of that queen. It has been tentatively identified by Mr. C. F. Bell as *Anne de Pisseleu, Duchesse D'Estampes*, but according to a manuscript note in seventeenth-century handwriting at the back, the portrait is that of *Claude Catherine de Clermont, Duchesse de Retz* (d. 1603), a lady of considerable importance at the court of Catherine de' Medici. It must, however, be added that this painting is somewhat different, particularly in the shape of the eyes and the chin, from the drawing by François Clouet in the Bibliothèque Nationale, reproduced in Bouchot's " Femmes de Brantôme " (p. 169). The inscription on the front of the panel is no doubt due to a misunderstanding of the words "Reine Catherine " appearing in the partly obliterated note at the back, the queen in question being Catherine de' Medici, consort of Henry II—combined with a failure to observe that the words HENRI VIII, ROI DE, are an interpolation by a later hand.

of the flesh, suggest that it is by some contemporary artist either copying an original miniature by Holbein, or perhaps working in his manner after the drawing of the Marchioness now in the Royal Collection. It was a comparatively common practice in the sixteenth century for an original drawing to be made *ad vivum* by the master, and for this to be passed from hand to hand for copying by other artists. This miniature was formerly called *Queen Catherine of Arragon*, and in the catalogue is said to have been in the Scott and Strawberry Hill Collections. But it is clear from the note in the Burlington Fine Arts Catalogue, above mentioned (p. 120), that the Catherine of Arragon "exquisitely finished, a round on a blue ground," which was given to the Duchess of Monmouth by Charles II, and passed from her daughter Lady Isabella Scott's collection to that of Horace Walpole, is the miniature No. c 5, now called *Queen Jane Seymour*.

ALTHOUGH at one time "a hand or eye by Hilliard drawn" was thought to be worth a "history by a worse painter made," this artist's miniatures have been sometimes criticized for the alleged flatness of effect due to the slight modelling of the features; and in this respect unfavourable comparisons have been made between his work and that of Isaac Oliver. More recent criticism, however, has placed the two styles in a truer relation to each other, and it is recognized that each artist perfected the method in which he found he could give most adequate expression to his artistic conceptions. Largely because the art of miniature portrait-painting was derived from that of illumination, but partly, no doubt, as the result of his study, or, as he put it, "imitation" of Holbein's manner, a conspicuous feature of which is his absolute mastery of the line, Hilliard thought that the principal part of painting after the life consists in the truth of the line, "for the lyne without shadowe showeth all to good judgment, but the shadowe without lyne showeth nothing." And if we (under the influence of Samuel Cooper) miss in his limnings the freer modelling which characterizes those of his pupil, it must at least be conceded that Hilliard's theory of miniature-painting is by no means indefensible,* nor without parallel. For it would have been accepted unreservedly as correct by a considerable body of artistic opinion, that of the East, where it has generally been thought that—to use Hilliard's expression—"a picture . . . so greatly smutted or darkened as some usse . . . is like truth ill towld;" and where, in consequence, the line has always dominated the shadow. Amongst the large number of miniatures by Hilliard in the collection, one of the most attractive is the portrait of his first wife, *Alicia*, daughter of *John Brandon*, Chamberlain of London, in her twenty-second year (B 5), in a contemporary frame of turned and carved ebony. Unfor-

* *Cf.*, for instance, Mr. T. Martin Wood's article on the Buccleuch Collection in THE STUDIO for January 1917.

4

tunately much of the delicate colour originally in the face has faded in the course of time, but the hair, the lace ruff, the dress, and the jewellery are painted with all that masterly skill for which Hilliard is famous (Plate XII). The miniature is dated 1578, and, apart from its æsthetic interest, also possesses great documentary importance, for it is one of the comparatively few in which there appears the artist's signature (in monogram) as well as the date and age of the sitter. In a border round the portrait in capital letters are the words "ALICIA BRANDON NICOLAI HILLYARDI QUI PROPRIA MANU DEPINXIT UXOR PRIMA." Half-way down the border on either side are representations of the arms of Brandon and of Hilliard, the former on the (spectator's) right, the latter on the left. According to the Dictionary of National Biography, Hilliard's father, Richard, is said to have been descended from an old Yorkshire family; and the writer understands that the arms of Hilliard in the miniature—*Azure, a chevron between three mullets pierced, or*—resemble those of the Hilliards, or Hildyards, of Holdernesse and Wynestead, Yorkshire, although presenting some variations from them. Thus, in the arms of the latter the mullets are usually not pierced; *argent* takes the place of *or*; and the *chevron* is noted by Burke as occasionally, though not invariably, part of them.

There are two other miniatures on which Hilliard's signature appears— the curious little self-portrait of the artist in his thirteenth year (AA 15), and the small round, said to represent *Edward, Duke of Somerset, K.G.* (DRA 18). Encircling the edge of the former are, in capital letters, the words "OPERA QUÆDAM IPSIUS NICHOLAIS HELIARD IN ÆTATIS SUAE 13 *; and of the latter, "EDWARDE DUKE OF SOMERSET ANNO DOMINI 1560." In the first case the letters N. H. (conjoined) and the date 1550 are in gold on the background; in the second the monogram N H forms part of the border. At the back of the limning of the Duke of Somerset in faded handwriting, apparently of the early eighteenth century, are the words: "King Edward ye 6th Governor."

The inscription on the self-portrait, taken in conjunction with the date 1550, raises a question of some difficulty, for it gives 1537 as the year of Hilliard's birth, and is thus in conflict with that on the well-known self-portrait of the artist in his thirtieth year in the Salting Collection. The earlier date is corroborated by another self-portrait, dated

* A replica differing only in the darker shade of the red background is in the Welbeck Abbey Collection. The Montagu House version was formerly in the possession of Mr. Hollingsworth Magniac, and in the catalogue of his collection was identified by Sir J. C. Robinson with the miniature which Walpole notes ("Anecdotes," p. 173) as having been in the cabinet of the Earl of Oxford. It is clear, however, from Mr. Goulding's Catalogue of the Welbeck Abbey Collection that the identification was erroneous, for the Duke of Portland's limning is No. 10 in Vertue's undated list, headed "A cabinet of curious Limnings—Lord Oxford's."

The frames decorated in black and white enamel containing this portrait, that of *Henry VIII* in his thirty-fifth year (c 7), and the *Boy unknown* called *Edward VI* (c 12), are Spanish work of the seventeenth century.

1574, in the Buccleuch Collection (B 19), but cannot be accepted as beyond question in view of the Salting miniature, the figures of the date on which are clear and untouched. If Hilliard was born in 1537, it is worth observing that he retained his full artistic powers for an unusually long period, since the miniature called *Lord Hunsdon* (AA 5), painted when he was sixty-eight, is executed with all his customary and wonderful command of detail. That is a great age at which to undertake such delicate work, but is not without parallel, for Simon Binnink painted his self-portrait, now in the Salting Collection, in his seventy-fifth year; and sitters were still flocking to Jean Petitot, the enamel painter, at the age of eighty. The second of these two miniatures raises even greater problems since it is dated eight years after the Protector's execution. It is possible that Hilliard may have executed a posthumous* portrait of the Duke of Somerset in the same way that he made the limnings, after earlier portraits, of Henry VII or Queen Jane Seymour, now in the Royal Collection, but this specimen (Plate V) is different from Hilliard's other work in style; the lettering in the border is less skilfully painted than that on the miniature of his first wife; and the features differ considerably from those of the Protector as represented in other paintings, *e.g.*, that reproduced in "Historical Portraits, 1400–1600" (P. 52). Moreover it is curious that in the period of twenty years before 1571 there should be only this limning, the self-portrait just described, and perhaps the *Lady Jane Grey* cited by Sir Richard Holmes in "The Burlington Magazine" (vol. viii, p. 233), but after that date examples for nearly every year until 1605, and possibly later.† In these

* A similar difficulty arises in connexion with the portrait of *Lord Hunsdon* already mentioned in the text, as it is dated 1605, and Lord Hunsdon died in 1596. This title is of long standing, although the features are not much like those in the portrait by Zuccharo exhibited at the National Portrait Exhibition of 1866 (No. 238). One or other of the three versions of this limning was engraved for Naunton's " Court of Queen Elizabeth," published by Caulfield in 1814, but in the edition issued ten years later, the engraving was abandoned in favour of another described as being after Marcus Gheeraerts. It is difficult to suggest a correct title however. The third Lord Hunsdon, who was alive in 1605, was not a Knight of the Garter as was the person represented in the miniature; and George, the second Lord, who was elected to that order, died in 1603. The features bear some resemblance to those of Sir Henry Lee, K.G. (d. 1610), in the painting at Ditchley, in which he is represented with his mastiff Bevis (see N. P. E. 1868: No. 676). It is worth adding that the portrait of *Lord Hunsdon* by Hilliard set in black enamel from Lady Germaine's collection which Walpole possessed, appears from p. 422 of the " Description of the Villa " to have been dated 1585.

† See the list of works by Hilliard compiled by Mr. Goulding for the Catalogue of the Welbeck Abbey Collection (p. 34). By MacKay the portrait of a *Man Unknown* in his thirtieth year, in 1612 (B 2), is also attributed to Hilliard, but this limning is so different in style from the others that it is difficult to accept the attribution as correct. If a genuine miniature of the time, it is more like the work of the son Lawrence than that of the father. The *Lady Unknown*, in her 19th year in 1608 (DRA 16), may be by " Old " Hilliard, but the face has been entirely repainted. In view of the motto, SI PERGIS PEREO, with which it is inscribed, and of the dagger in the lady's hand, this miniature may reasonably be identified as "Lucretia," or some one in that character.

circumstances its ascription to Hilliard appears open to question, although no doubt it is of a considerable age.

Another very interesting painting by Hilliard is that of *George Clifford, Earl of Cumberland, K.G.* (DRA 7), hero of the Tilt-yard and naval commander, who in 1588 commanded the "Elizabeth Bonaventure" of 600 tons in the fights against the Spanish Armada, and after the successful action off Gravelines carried the news of victory to Tilbury. He is represented (Plate XVII) in the character of the Queen's Champion, clad in armour of blue steel with gold stars of eight points, and wearing in his hat the glove which Queen Elizabeth allowed him to keep as a mark of her appreciation of the courage and dexterity which he displayed in games of chivalry. The device or *impresa* appearing on the shield to the right of the picture is a personal one, of which no other record has been traced. It consists of a representation of the earth between the sun and the moon upon a field azure with a short motto, which is partially undecipherable. It has not been possible to identify the cathedral and other buildings sketched in the background.

The adoption of a motto or device for purely personal reasons was not unusual in those days of mock-chivalry. It is recorded, for instance, by Sir William Segar, Norroy King-at-Arms, in his "Honour Military and Civil," printed in 1602, that for several days after the tournament mentioned below, Sir Henry Lee wore a cloak embroidered with a crown and a certain motto or device, "but what his intention therein was himself best knoweth;" and it is possible that the motto, "Free from all filthie fraude," appearing on the portrait of *Sir George Carey* (AA 14), may be of such a character. For the miniature is dated 1581, on the 1st January, in which year Sir George Carey with other gentlemen of the Court, including Mr. Francis Knowles, whose portrait is also in the collection (AA 4), were the "Defenders" in a "Royall combat and fight on foote" before Queen Elizabeth. The "Defenders" also included Thomas, Lord Howard of Bindon, the father of the *Viscount Bindon* mentioned below, and of *Frances Howard, Duchess of Richmond and Lenox* (DRA 25), whose portrait is reproduced on Plate XXII.

The Earl of Cumberland was installed a Knight of the Garter in 1592, and as he is represented without the Order, there is a strong probability that the portrait was painted before that year. It is possible that it was made in connexion with the great tournament held on the 17th November 1590, at which he was accepted as the Queen's Champion in place of Sir Henry Lee, who had previously performed that office at

She is paralleled by the figure of a lady stabbing herself at a banquet on an almost contemporary panel of English "petit-point" embroidery in the Museum (T. 125-1913). The latter is, no doubt, meant to represent Lucretia, as the other figures in the panel are taken from an engraving by Philip Galle representing the banquet given by Sextus Tarquinius in camp under the walls of Ardea, the discussion at which led to his meeting Lucretia, and to her subsequent rape and suicide.

the annual exercises of arms, founded in celebration of the day of her accession.* It must, however, be stated that on an old print, either after this limning, or a replica belonging to Mr. Lawrence Currie, the title runs: "George Earl of Cumberland, 1586"; and it may be that the engraver added that date because he thought, or had reason for supposing, that the original was painted to celebrate the presentation of Her Majesty's glove, which appears to have been made in or about that year, either after a tournament or, according to another account, at an audience granted upon the conclusion of one of his expeditions, the first of which was made in 1586.

The collection contains several miniatures by Hilliard which are said to represent Queen Elizabeth, but the learned writer of a note in the "Burlington Magazine" for September 1916 (p. 303), expressed a doubt whether any of them can be regarded as authentic portraits. There are two, however, which may be accepted as such, although in both cases the Queen's features have been much restored. The first is the small oval (c 10) inscribed ". . . DNI . . ." in which Her Majesty is represented in a grey dress trimmed with white, yellow, and green bows (Plate V). The second is one of the eight portraits in the well-known ebony frame, which was at one time in the collection of Charles I, and is branded at the back with the Royal Cipher.† According to Van der Doort this limning was done by "Old Hilliard" and bought by the King of "Young Hilliard," i.e., the son Lawrence, who succeeded his father in the office of King's Limner. For the rest, the style of costume, belonging as it does to the second half of the sixteenth century, makes it impossible that the attractive miniature, said to represent Queen Elizabeth when Princess (c 14, Plate V), should be a portrait of her: and in the two other so-called portraits which we illustrate (c 18 and cc 6, Plate IV) the shape of the forehead and nose, indeed of the face generally, makes it difficult to accept either title as correct, although each is of considerable standing. A similar difficulty arises in the case of another so-called portrait of the Queen (c 16) by Isaac Oliver, in which she is represented in a dress ornamented in the Italian style, in opaque colours heightened with gold (Plate XIV). O'Donoghue, in the Introduction to his "Catalogue of The Portraits of Queen Elizabeth" (p. xii), asserts that although no doubt Oliver painted Elizabeth,

* A full description of that curious ceremony will be found in Miss Aikin's "Memoirs of Queen Elizabeth," vol. i, p. 259.
† In 1842 this group of Tudor Portraits appears to have been in the possession of the Duke of Richmond. The circumstances in which it left him are not known, but about 1860 the frame was acquired by Messrs. Colnaghi for the Duke of Buccleuch. From the same source shortly afterwards came the small frame containing portraits of *King James I, Queen Anne and their Family*, with the Royal Arms in the centre (D 8), which was at one time in the possession of Queen Caroline: it is No. 88 in Vertue's catalogue of her collections. Unfortunately all these miniatures have, with the exception of Queen Mary I in the first group, been severely damaged by repainting.

no authentic miniature of her by his hand exists; and in any case the features of the lady in this limning are quite unlike those of the Queen. In the Burlington Fine Arts Catalogue, already quoted, this portrait was tentatively identified as that of Lady Arabella Stuart.

ALTHOUGH Holbein, Hilliard, and Oliver, whose work will be considered later, were the principal miniaturists of the sixteenth century, there were several other artists contemporary with them who worked in this method with success. In the first half of the century there were, for instance, Simon Binnink and his daughter Livina, Luke Hornebolt and his sister Susannah; and Dr. Propert has expressed the opinion that one of these may well have executed the portrait of *Henry VIII* in his thirty-fifth year (c 7), in which the king is represented with the long hair and shaven chin, which were in fashion until his decree of the 8th May, 1535. It is significant of the extent to which Persian miniature painting was influenced by motives derived from European illumination, that to the angels represented in the spandrils of this limning (Plate VII) there is a curious parallel in a Persian MS. of the Timurid School, dated nearly one hundred years earlier, on the first leaves of which somewhat similar angels with scrolling bands form part of the decorative border surrounding a central compartment, which contains the text.* Antonio More sometimes painted portraits in little, and of his work the collection contains one superb example, the miniature of *Queen Mary I*, in a dress of cut velvet and gold tissue (c 8). The rose and the glove† which she is represented as holding (Plate VIII) are also to be seen in the nearly full-length portrait by More, now in the Prado, but the Queen's features are less severe and unattractive in the miniature than in the painting. The latter was painted in the autumn of 1553 while the negotiations were being conducted for the Queen's marriage to Philip II; and presumably the former was done about the same time. It is painted in oil on a gold plate, and is one of the group of Tudor Portraits already mentioned, having been given to King Charles I by the Earl of Suffolk.

In the second half of the century there is mention of Francis and William Segar, John and Thomas Bettes, Nicholas Lockey, and others, including one John Bossam, who was noted by Hilliard as working mostly in black-and-white, "belike wanting to buy fairer colours."

* See "Miniature Painting in Persia, India, and Turkey," by F. R. Martin, vol. ii, p. 243.
† The glove was not infrequently introduced into More's portraits, and was indeed an important, not to say expensive, detail of the costume worn by important personages in the sixteenth century. The story is told, for instance, that Queen Elizabeth was so pleased with a pair which she accepted from the Earl of Oxford that she had herself painted with them: and earlier in the century a certain Mrs. Croake, in gratitude for a decision given in her favour, sent to Sir Thomas More on the following New Year's Day a pair of gloves containing fifty angels. The Chancellor accepted the gloves, but returned what he happily called the " lining."

Authentic miniatures by any of these are practically unknown, and particular interest attaches therefore to the portrait of a *Man Unknown*, in his twenty-third year in 1553, in oil on silver (s 21), as it bears a signature "F. S.," which may very possibly stand for the first of the above. As will be seen from the illustration (Plate IX), the miniature suffers from its rather wooden draughtsmanship, and it is in this respect inferior to another in oil, reproduced on the same plate and called *The Countess of Huntingdon* (B 11) by an unknown artist working some twenty years later. Several miniatures in the collection are said to be by John Bettes, but they differ considerably in style from one another, and can scarcely all be by the same hand. It is possible, however, that the portrait of a *Man Unknown* dated 1580 and signed "B" (G 10), may be by him, though its lowness of tone is in marked contrast to the brilliant colouring which characterizes the portrait of Edmund Butts by this artist in the National Gallery. Four further limnings by unknown artists of the sixteenth century may be mentioned. The first is a doubtful portrait of *Sir Walter Raleigh* (AA 2) ; the second, in a carved ivory box, is the portrait of a man in his forty-second year in 1541, inscribed *Vive ut vivas*, and said to be *Sir Francis Drake* (AA 18) ; the third represents *Thomas, Baron Seymour of Sudeley, K.G.* (B 14), the brother of the Protector Somerset ; while the fourth (s 22), dated 1584, may be *Sir Horatio Palavicino*, collector of the Papal taxes in England, who, upon the change of religion which followed Elizabeth's accession, stayed in this country—with the taxes, and by their means laid the foundations of an enormous fortune. In the words of his epitaph, "he robbed the Pope to lend the Queen"; and so deeply was Elizabeth in his debt that it was said the fate of the country depended upon him.

IT is practically certain that Isaac Oliver studied under Hilliard, and, as might be expected in such circumstances, it is sometimes difficult to determine whether a particular specimen is by the latter or the former. Thus the miniature of *Sir George Carey* (AA 14), which is attributed to Oliver in the catalogue, appears in the list of Hilliard's works compiled by Mr. Goulding for the Catalogue of the Welbeck Abbey Collection (p. 50). Conversely, the miniature representing *Frances Howard, Duchess of Richmond and Lenox* (DRA 25), which is ascribed to Hilliard, may be by Oliver. Amongst the signed examples by Isaac Oliver in this collection the most noteworthy is the circular portrait of *Lucy Harington, Countess of Bedford*, patroness of poets and a lady of great importance at the Courts of Queen Elizabeth and King James I. With the latter's Queen she was on terms of special intimacy, and the two ladies frequently played together in the masks which formed a favourite diversion at the Court. The subtle modelling of the features, achieved without any strong contrasts of light and shade, the brilliant drawing of the finely-shaped hands, and the skilful paint-

ing of the brightly-patterned dress, render this a particularly attractive and interesting example of Oliver's art (Plate I). A similar limning is in the Pierpont Morgan Collection, and in the catalogue of that collection is given by Dr. Williamson to John Bossam, mentioned in the preceding paragraph. Another signed miniature of considerable charm is the portrait somewhat doubtfully said to represent *William Drummond of Hawthornden*, the poet (B 33). Of *Henry Frederick, Prince of Wales*, upon whose untimely death (from typhoid in his nineteenth year) Drummond composed an elegy, there are two portraits. The first, in profile (D 4), represents him as a young man "in a red scarf, after the Roman fashion." The second is the charming drawing of him as a boy, which we reproduce on Plate XVIII. The former was in the collection of Charles I, and possibly in that of Horace Walpole at Strawberry Hill. The latter is from Lord Northwick's Collection, and in the sale catalogue was attributed to Isaac Oliver, but the correctness of this attribution has since been doubted. In any case, as the writer in "The Burlington Magazine" pointed out, the name Oliver appearing at the right hand bottom corner is in a modern hand. Amongst the unsigned examples the more interesting are *Lady Arabella Stuart*, great granddaughter of Margaret Tudor, the sister of Henry VIII, and so next to James I in succession to the throne (B 36); a *Lady* doubtfully said to be *Frances Walsingham, Countess of Essex*, whose marriage to Robert Devereux, Master of the Horse, brought him into disfavour with Queen Elizabeth (DRA 8); *Sir Philip Sidney*, Spenser's "President of noblesse and chivalry" (DRA 17); and a *Lady Unknown* called *Anne Clifford, Countess of Dorset and Pembroke*, whose overdress of cut work is painted with extraordinary skill (DRA 22, Plate XIII).

The miniature inscribed "HENRICUS VII D. G. ANGLIAE ETC. REX" (C 3, Plate VI), which was formerly in the collection of Charles I, having been brought from Germany and given to the King by "the Lord Ambassador, Sir Henry Vane," cannot, in view of the style of costume, be a portrait of that king: nor is it by Oliver, to whom, after Holbein, it is attributed in the catalogue. It is, as Scharf hinted ("Archæologia," vol. xxxix, p. 271), of foreign * origin. For the flaming vase represented on the doublet was one of the devices of René, Duke of Anjou, King of Sicily—it appears very prominently, for instance, on the great coat-of-arms in enamelled terra-cotta, by Luca della Robbia, in the Museum—and we may infer, therefore, that the person portrayed is one of his descendants. Mr. Van de Put, who drew the writer's attention to the significance of the vase, has suggested that the portrait may

* The carved cedar and boxwood frame containing this miniature also appears to be French, though somewhat later in date. It is very similar in design to some of the mounts on gems of the second half of the sixteenth century in the Bibliothèque Nationale, see especially No. 1002 on Plate 65 of Babelon's "Catalogue des camées antiques et modernes de la Bibliothèque Nationale."

be an early one of Nicholas d'Anjou (b. 1518), great grandnephew of René, created Marquess of Mézières, in Touraine, in 1567. Unfortunately no other early portrait of him has been met with ; and the drawing in the Musée Condé at Chantilly, executed about 1550, represents him later in life and wearing a beard. The four "little flowers called heartsease" in the sitter's right hand are apparently purely ornamental. According to Scharf, similar flowers appear on a miniature of the Queen of Bohemia, when young, in the Royal Collection.

OF the work of Isaac Oliver's eldest son Peter the collection contains several notable examples, many of which are signed. Of special interest are the portraits of *George Villiers, Duke of Buckingham, K.G.*, the celebrated favourite, an exceedingly fine miniature, unfortunately somewhat retouched (B 29, Plate XX); *Lady Arabella Stuart* (?) (DRA 14); *King Charles I* (A 4); *Frederick, Elector Palatine, King of Bohemia*, of whom there are two* portraits by Peter Oliver, DSRB 8 and DRSB 14, the latter bearing the (spurious) signature and date "I. O. 1624"; and a miniature erroneously said to be a self-portrait of the artist (B 15). The last is, perhaps, a portrait of oue of his brothers, as Sir Richard Holmes suggested in "The Burlington Magazine" (vol. ix, p. 110), when discussing a limning in the Royal Collection wrongly engraved by Houbraken in the "Illustrious Heads" as a portrait of Ben Jonson (Plate XIX). Besides the above there may be mentioned the *Man Unknown* called *Sir Edward Osborne* (AA 9 †), who from being an apprentice rose to be one of the principal members of the Clothmakers' Company and Lord Mayor of London; *Thomas Howard, Third Viscount Bindon, K.G.* (DRA 23 †); *Sir Robert Shirley* (DRB 27), in the Oriental costume which he affected; and *Sir Kenelm Digby* (DRB 34), one of the most remarkable men of his day, who was at different times naval commander, diplomatist, and man of science.

The miniature, now called *Sir Robert Shirley* (Plate XVI), was at one time in the possession of Horace Walpole, who identified it, though evidently with some doubts, as a portrait of the brother Sir Anthony; and on the strength of this identification it was engraved for the biographical note on Sir Anthony Shirley in Moule's "Illustrious Persons," 1869. But the features correspond closely with those of Sir Robert in a painting at Petworth, and it is clear that the present title is correct. The miniature of *Sir Kenelm Digby* is inscribed *Morte; altro ben homai non spero*; and it is possible that this motto, "Death; for other good henceforth I do not hope," may give a clue to the date. For its adoption

* There is a third portrait of this Prince when young (DSRB 4), also said to be by Peter Oliver, but in style closely resembling the work of the father.
† Both of these are attributed to Isaac Oliver in the catalogue, but may very possibly be by the son. In view of the style of costume the former can scarcely represent Sir Edward Osborne, who died in 1591.

12

would be natural enough if the miniature was painted somewhere about the time of his wife Venetia's death, which occurred unexpectedly in 1633, and plunged Sir Kenelm into such profound grief that he spent the next two years in seclusion at Gresham College. If this is so, one may perhaps go further and see in the sinking ship represented in the background, an allusion to the havoc wrought in his life by his wife's untimely end.

THAT there were two* miniature painters of the name of John Hoskins, father and son, may now be accepted as almost beyond question. That their work can be distinguished by the signature, as Vertue thought, is more open to discussion. Certainly those miniatures in the Buccleuch Collection,† which are signed with a monogram similar to that on the alleged portrait of John Hoskins the elder reproduced on Plate XXVI, differ in treatment from those signed "I. H." or "H" to an extent which suggests that the two groups are by different hands, the former by an artist working in a manner akin to that of the sixteenth-century miniaturists, the latter by one working in the style which was brought to such perfection by Samuel Cooper (see Plate XXVIII, on which typical examples of each of the three styles are reproduced). Mr. Goulding, however, points out in his notes on Hoskins that this difference of technique does not apply to all cases, and in these circumstances Vertue's theory can only be regarded for the present as a good working hypothesis. With this reservation it has been adopted in the following classification. One of these two artists described in a memorandum attached to his will as "John Hoskins the elder, limner of Bedford Street," died in February 1664–5; and it has generally been considered that this was the father. But the scanty evidence available suggests that he may have been, as Mr. Goulding thinks, the son; or in other words that there were three of the name, two of whom were limners. It is known from an entry in Pepys' Diary that "Mr. Cooper's cosen Jacke" Hoskins was alive in 1668, and it is probable that he was living in 1672 as he is mentioned in Cooper's will, which was proved in July of that year. Now the last example signed "I. H." in Mr. Goulding's list is dated 1663, and if "cosen Jacke" was the artist using these initials, it is curious that there should be no signed minia-

* See in this connexion the notes on John Hoskins in Mr. Goulding's Catalogue of the Welbeck Abbey Collection (p. 36), and Chapter I in Mr. J. J. Foster's "Samuel Cooper and the English Miniature Painters of the Seventeenth Century."

† We may include also the miniature said to represent *Mary Sidney, Countess of Pembroke* in the Madresfield Court, and the portrait of a *Man Unknown* (No. 679) in the Museum Collection. The difference is observable not only in general treatment, but also in matters of detail, the lace collar, for instance. Two of the examples in the Buccleuch Collection, *Sir Benjamin Rudyerd* (B 17) and the so-called *Sir John Harington* (B 40), have been so much restored that the original painting has practically disappeared.

ture after that date. On the other hand, if it was "cosen Jacke's" father who died in 1664–5, it is natural enough that his grandfather's limnings should resemble those of the sixteenth century in style.

Of the miniatures by the elder Hoskins the first to be mentioned should certainly be the exquisitely painted portrait of *Robert Carr, Earl of Somerset, K.G.* (R 12, Plate XXVIII), Lord Chamberlain to King James I, and notorious for his share in the imprisonment of Sir Thomas Overbury, his one time intimate friend and adviser. From an iconographical as well as artistic point of view considerable interest attaches to No. B 23, called a self-portrait of the artist (Plate XXVI.) It was engraved as such by Harding in 1802 for the note on John Hoskins in the "Biographical Mirrour" (vol. iii), but the correctness of the title has since been called in question; and as Harding was aware of Walpole's note that Lawrence Cross possessed the only known portrait of Hoskins (a head almost profile in crayons) and that he did not know what had become of it, it is unfortunate that Harding has not recorded his reasons for reproducing this miniature as the illustration. According to a statement at the foot of the engraved plate the original was then in the possession of W. E. Sotheby, and he may have had grounds for identifying it with the "profile" noted by Walpole as belonging to Colonel Sothby, which Vertue thought might be Hoskins himself ("Anecdotes," p. 380). It was interesting to find that the same sitter, perhaps grown a little older, is represented (in profile) as the central figure of a skilfully composed group with his wife and four children, in a sketch, also, no doubt, by Hoskins, on the back of the card. To the elder Hoskins, too, is usually attributed the limning of *King Henry VIII* (c 25), after a sixteenth-century original, either c 7 already mentioned, or the replica in the Royal Collection. This copy is said to have been in the possession of Charles I, having been given to him by the Earl of Suffolk; and a note pasted on the frame states that the back is endorsed: "In the Cubberd within ye Cabonett rooms at Whithall 1638." It is worth adding that, according to Scharf, one of the versions at Windsor bears a somewhat similar inscription: "In the cubborde within ya cabont roome at Whitehall 1638." Two other miniatures done by Hoskins for Charles I, each after "an ancient oil-colour piece," and representing respectively *Elizabeth of York* and *Anne Boleyn*, are among the Tudor Portraits already mentioned, but, like the others, have been much repainted.

OF the work of the younger Hoskins there are numerous examples in the collection, most of them dated as well as signed. Nearly all are of fine quality, but some—*e.g.* the portraits of *Frederick, King of Bohemia* (DSRB 2), *General Davison* (DRB 8), both on Plate XXVII, and one doubtfully called *Sir John Suckling* (DRB 28, Plate XXVIII)—indicate how high was the standard which he reached when at his best. Indeed, in

breadth of treatment the three limnings just mentioned are comparable with those of his illustrious nephew and pupil. Other noteworthy examples are a *Lady Unknown*, erroneously called *Elizabeth Vernon, Countess of Southampton* (cc 12, Plate XXVII); another doubtfully said to represent *Anne Rich*, a daughter of the Earl of Warwick, who married in 1664 Thomas, son of Sir John Barrington (R 24); a third called *Lady Isabella Scott* (Q 8); and *Edward Montagu* (P 19). This Edward Montagu, the eldest son of the second Baron Montagu, was killed at Bergen in 1665, in an attack on the Dutch East India Fleet, and should be distinguished from his cousin of the same name, created Earl of Sandwich, who was blown up or drowned at the battle of Southwold Bay in 1672. The miniature, doubtfully said to represent *John Evelyn* (R 19), is attributed to Hoskins in the catalogue, but is different in style from the work either of the father or the son, and is probably by some other artist of the seventeenth century. On the other hand, the excellent unsigned limning called *John Oldham* (DRB 29), which, unfortunately, has suffered considerably in the course of time, is very possibly the work of the younger Hoskins. No. BB 9, described in the catalogue as the portrait of *A Man Unknown*, which we reproduce on Plate XXVI, is noteworthy for the appearance of the word "I P S E" in gold letters under the signature and date, 1656. As it is apparently in the same hand, we may conclude that this is a self-portrait of the artist—*i.e.* the younger Hoskins, the initials being written separately.

IN the history of miniature-painting in this country no name, except that of Holbein, is so well known or so justly famous as that of Samuel Cooper. By a happy chance the times produced the man, and Cooper, by his inimitable art, has faithfully recorded for posterity the appearance and the character of many of the great men and women of one of the most stirring epochs in English History. First in importance amongst the many choice examples of this master's work in the Buccleuch Collection is certainly the well-known portrait of *Oliver Cromwell* (Plate XXX), exhibited in the frame* which also contains the portraits of his wife and one of his daughters. Unfinished, except as regards the face, this limning is said to be the copy which the Protector took away from Cooper when he caught him in the act of making it. A similar miniature is in the possession of the Duke of Devonshire, and Sir Richard Holmes has expressed the opinion that the Devonshire portrait is the original,†

* This frame was acquired by the Duke of Buccleuch from a descendant of the Frankland family, into whose possession it came originally through Cromwell's daughter, Mrs. Claypole. To judge by the style of decoration, the buttons exhibited with the miniatures date from the second half of the seventeenth century.

† See, however, Mr. Goulding's note on the version by Bernard Lens in the Welbeck Abbey Collection (No. 121 Cat. p. 113). A drawing in pencil on paper by Cooper giving the same view of Cromwell's face belongs to the Duke of Sutherland. Very probably this is the original upon which both these miniatures are based.

of which this is the copy. Neither version is dated, but from a note in the catalogue of the National Portrait Gallery (p. 110) it appears that the year to which they belong is 1657, the culminating year of the Protector's career.* It is unnecessary in these notes to dwell upon the amazing power which Cooper has displayed in this superb limning, as the work has been praised by every writer on the subject, and by none more eloquently than Horace Walpole, who in a much quoted passage in the "Anecdotes" observed that if it were enlarged, "I don't know but Van Dyck would appear less great by the comparison."

There are a few miniatures by, or attributed to, Cooper of various members of the Protector's family, which, although perhaps of somewhat less artistic importance than others by him in the collection, may be conveniently dealt with here. No. F 20, not signed, but in all probability by Cooper, is said to represent Cromwell's eldest surviving son, Richard, who for a brief period succeeded his father in the office of Protector (Plate XXXVI). But it does not agree with the miniature † by Hoskins in the Royal Collection, nor with that by Cooper lent to the 1865 Exhibition of Miniatures (No. 2884), nor with the painting by Robert Walker at Chequers Court, exhibited at the National Portrait Exhibition, 1868 (No. 733). It has been reproduced by Gardiner in his "Oliver Cromwell" (p. 160) as a portrait of Henry, the youngest son, and this identification is no doubt correct, as the miniature agrees with the latter's portrait at Chequers Court (N. P. E. 1868: No. 732), and with two contemporary engravings in the British Museum cited in the introduction to that volume, p. iv. This being so, No. F 3, also attributed to Cooper, must, if a Cromwell portrait at all, be taken to represent Henry rather than Richard, and F 13 (inscribed "S. C.," but clearly not by Cooper) as Richard rather than Henry. As regards the daughters, there is a miniature, unfortunately somewhat faded, of *Mrs. Claypole* (Q 4, signed and dated 1652), which closely resembles another of her by Cooper in the Royal Collection,‡ and may be accepted as correct. Both of these, however, differ from that called *Mrs. Claypole*, which is exhibited in the frame with the Protector and Mrs. Cromwell, to an extent which makes it necessary to suggest that the last is a portrait of another of the children, perhaps Frances, the

* Besides this portrait, and the copy by Richter, after Cooper, mentioned below (F 8), there are two others of the Protector, both of which are in profile (F 1 and F 11), after a drawing by Cooper, in indian ink, in the possession of the Duke of Devonshire. A fifth (F 2) is perhaps after a portrait by Robert Walker.

† Reproduced in an article on Oliver Cromwell, by Viscount Morley, in the "Century Magazine," vol. xxxviii (1900), p. 878, *q.v.* For a reproduction of the painting of Mrs. Claypole by Robert Walker in the National Portrait Gallery, see Mr. Cust's Catalogue, vol. i, p. 105.

‡ Reproduced *ibid.*, p. 875, and "Burlington Magazine," vol. ix, p. 298. The collection contains a third miniature said to represent Mrs. Claypole, No. N 6, but the title is evidently incorrect in view of the style of hair-dressing, which was not in fashion until after Mrs. Claypole was dead.

youngest, who married Robert Rich, and as her second husband, Sir John Russell, Bart., of Chippenham, eldest brother of Henry Cromwell's wife (N. P. E. 1868; No. 721). The first marriage was noted because at the wedding "they had 48 violins and 50 trumpets, and much mirth with frolics, besides mixt dancing (a thing heretofore accounted profane) 'till 5 of the clock in the morning." There is finally a miniature (No. DRB 4, attributed to Cooper, but possibly by Hoskins), which is said to be *Mary Cromwell* (Plate XXIV), " a wise and worthy woman, more likely to have maintained the post than either of the brothers," and the wife of Thomas Belasyse, created Earl of Fauconberg, who in consequence of her prudent management (as it was generally thought) was privy counsellor to Oliver, Richard, the restored Stuarts and King William. But although this portrait agrees in some respects with that at Chequers Court (N. P. E. 1868; No. 729), it appears to differ in others—notably the colour of the hair; and the title is therefore accepted with some reserve.

Of Fauconberg's cousin, *John, Baron Belasyse*, who fought for the King at Edgehill, Newbury, and other battles, there is a singularly attractive miniature (DRB 25), the interest of which is enhanced by the fact that it is one of the few examples extant signed in full (Plate XXXV). The hair and armour are drawn with all Cooper's customary skill, and in the face are very clearly apparent the "noble qualities" which Fuller says Lord Belasyse possessed. Perhaps the treatment of the hand holding the baton is by comparison weak, but to the end of his career, as Sir Richard Holmes has pointed out, Cooper never succeeded in painting hands, and if he could so arrange it, left them out. Several others of those who supported the Royal Cause are to be met with in this section of the collection, *William Cavendish, Duke of Newcastle, K.G.* (Plate XXXIII), looking exactly as he was described by Clarendon, "a very fine gentleman" (DRB 17); *James Graham, Marquess of Montrose* (?), one of the ablest soldiers of the day (DRB 18); *Sir Adrian Scrope*, of Cockerington, who with his father, Sir Gervase, fought at Edgehill (AA 11); and most famous of all, *Prince Rupert, K.G.* (A 31), his face hardened by years of strenuous fighting. *George Monck*, created Duke of Albemarle and a Knight of the Garter in 1660 " for his princely blood and signal services," his title being derived from a place in Normandy formerly belonging to the Plantagenets, Richard Beauchamp, Earl of Warwick, and Arthur, natural son of Edward VI, from whom Monck claimed descent, is represented in two miniatures (P 18 and R 6). Both of these are very skilfully painted, but even when allowance is made for differences due to the age at which the " Lord-General " is shown, it is difficult to regard the first title as correct.* Be that as it may, the second miniature is un-

* The opportunity may be taken to advert to two other titles, the correctness of which is open to question. The miniature said to represent Sir John Maynard (F 6) bears no resemblance to his portrait by an unknown artist in the National Portrait Gallery, nor

doubtedly an authentic presentment of that great soldier (Plate XXXII), in which Cooper very successfully conveys a sense of the solidity observed in Monck's bearing by a French visitor to London in 1663. But the two most distinguished of all Cooper's portraits of men in this collection are *King James II*, when Duke of York (A 28), and *James Scott, Duke of Monmouth and Buccleuch, K.G.* (O 2 ; where it is called in error Philip Stanhope, Earl of Chesterfield). The painting of the hair in these two miniatures is executed with unusual delicacy, even for Cooper, but the artist has been still more successful, if that is possible, in portraying the characters of the two Princes (Plates XXXII and XXXI), the first proud and handsome, if a little melancholy and cynical, the second astonishingly beautiful, but richer in good looks than mental attainments or self-restraint. Painted in 1667, when Monmouth was eighteen, this miniature makes it easy to understand that he was, as Grammont describes him just about this time, the universal terror of husbands and lovers. It is strange how like he is in it to Col. Robert Sidney (as represented in a painting at Althorp), who was considered by many, including James II and Evelyn, to have been his father, notwithstanding the public acknowledgment by Charles II. The wart on the face, noted in the "Life of James II" as common to both, is very apparent in the miniature.

For the most part Cooper's portraits of women are as clever as those of the men, though possibly not so flattering to his sitters as they would have wished. If for some reason he spares *Barbara Villiers* * (N 5), and except for the swell of the underlip, gives no hint of the character for which she is notorious, there is that in the face of the lady erroneously called *Lady Heydon* (R 36) which inevitably suggests that the sitter is to be found among the frailer beauties of the Restoration. She is without doubt *Margaret Brooke*, Lady Denham, whose shameless immodesty in relation to the Duke of York is well known (Plate XXXVI). Of the other portraits, the more noteworthy are *Mary, Princess Royal*, to the miniature by Hoskins in the Pierpont Morgan Collection, which agree with one another. In fact the title is comparatively modern. For the miniature was purchased at the sale of Lord Northwick's Collection in 1863 (Lot No. 634), and it was then called *Dr. Bate*. MacKay states that it was formerly at Strawberry Hill, but the writer has not been able to trace it, either in the " Description of the Villa " or the Sale Catalogue of the collection. Walpole certainly possessed a portrait of Sir John Maynard, but it was by Hoskins, and is the one just mentioned as being in the Morgan Collection. The portrait of *John Milton*, when young (F 9), was discussed by Dr. G. C. Williamson in the publication issued in connexion with the Milton Tercentenary Exhibition at Cambridge in 1908 (p. 22). To the reasons there given for doubting the correctness of the title, it may be added that the collar represented in the miniature was not worn at a time when Milton was at the age of the sitter.
* This identification is suggested by the writer following a clue given by Sir Richard Holmes in the "Burlington Magazine," vol. ix, p. 368. The lady represented in R 36 has her hair dressed in the fashion of the period, c. 1663-1673, and therefore cannot be Lady Heydon, wife of Sir John Heydon, Lieutenant-General of the Ordnance to Charles I, as she died in 1642.

who married William, Prince of Orange,* and so became the mother of King William III (cc 4) ; *Lady Mary Fairfax, Duchess of Buckingham*, the only daughter of Thomas, Lord Fairfax, and "a most virtuous and pious lady in a vicious age and court"(N 23); *Lady Penelope Compton*(?), wife of Sir John Nicholas, K.B. (N 9) ; and a portrait said to represent *Charlotte de la Trémouïlle*, but dated seven years after her death, and bearing little resemblance to Van Dyck's painting of that stout-hearted lady (R 4). This miniature, which may be tentatively identified as *Margaret Leslie*, *Lady Balgony*, afterwards, Countess of Buccleuch, and by a third marriage of Wemyss, is the last of Cooper's dated works in the list compiled by Mr. Goulding ; and were no other evidence available, the vigour with which it is painted (Plate XXVIII) would prove conclusively that when Cooper died his powers of artistic expression were still at the full. In point of fact, from a letter † written by Mr. Charles Manners to Lord Roos on May 4, 1672, and brought to light by Dr. Williamson, it appears that Cooper died, after a few days' illness, with the miniature of " my Lady Exester," only just begun.

IN Samuel Cooper the art of limning reached the highest standard of excellence. Many exquisite miniatures were painted after his death, particularly in the later years of the eighteenth century, but in his power of portraying character he was never equalled. He marks a turning-point in the history of the art, and it will be convenient to pause for a moment at this stage, in order to notice a few miniatures in the collection by artists working in the first half of the seventeenth century, but for the most part unidentified. To the early years of the century must be assigned the limning (B 16) called *Sir Walter Raleigh*, but possibly representing *Sir Thomas Overbury*, the victim of the " poisoning" Countess of Essex, who married Robert Carr, Earl of Somerset, above mentioned. The miniature of a *Man Unknown*, dated 1611 (G 19), in oil, may be identified as *William Drummond of Hawthornden*, whose portrait by Cornelius Johnson, dated 1612, is in the possession of the Earl of Home. To Johnson, who is recorded by Walpole to have made copies in little of some of his paintings, may perhaps be attributed, as Mr. Goulding has suggested, the delicately-painted miniature in oil, No. G 2, which is clearly a portrait of *Thomas, Baron Coventry*,‡ Lord Keeper of the Great Seal in the reign of Charles I (Plate XXI). *Elizabeth of Bohemia*, whose features are made so familiar

* Burnet relates a curious story ("History of My Own Time," p. 570) that it was foretold of this prince that he would have a son by a widow and would die of the smallpox in his 25th year. The future King of England was born (prematurely) a week after his father's death of that disease.

† See THE STUDIO SPRING NUMBER, 1910, p. 12 : the letter is reproduced in facsimile in Dr. Williamson's Catalogue of the Pierpont Morgan Collection.

‡ *Cf.* the portrait of *Baron Coventry*, after Johnson, in the National Portrait Gallery; reproduced vol. i, p. 77, of Mr. Cust's Catalogue.

by Peter Oliver's limnings, appears in a carefully-drawn miniature, in oil, in a turned ivory case (D 6) ; and the famous *Thomas Wentworth, Earl of Strafford*, in No. DRB 13, which, if after Van Dyck, is none the less an impressive portrait of that great statesman. A somewhat curious painting (AA 8), also dating from the first half of the seventeenth century, is said to represent the adventurer *Sir Anthony Shirley*, who went to Persia with his brother Robert in 1599; was given the rank of Mirza by Shah Abbas the Great, and received a firman granting rights of trade in all parts of the Shah's dominions for ever. In view of the strangely swollen appearance of the face and hands, it is worth recalling that, according to a tradition, which the writer understands survived in Persia until a comparatively recent date, Sir Anthony Shirley was addicted to drink. Indeed, in his portrait by a contemporary Persian artist, reproduced in "The Journal of Indian Art" for October 1896, he is represented with a "Shiraz" wine-bottle under his arm.

To Samuel Cooper's brother Alexander, who worked principally abroad, is to be attributed the portrait of *Charles Louis, Count Palatine*, the brother of Prince Rupert (A 30), with an attractive mauve background ; and to this artist, perhaps, should also be ascribed another portrait of this prince (DSRB 5), catalogued as by Peter Oliver, but in style closely resembling the miniature just mentioned. On the other hand, *The Lady Unknown* (P 14), appearing in the catalogue as by Alexander Cooper, is so different from either of the above (and from the other examples by this artist reproduced by Dr. Williamson in his "History of Portrait Miniatures"), that it can scarcely be by the same hand. The miniatures of *Edmund Waller* (?), the poet (BB 1), and *Samuel Butler*, the well-known author of "Hudibras" (Q 11), are usually said to be by Samuel Cooper, but the attribution in each case is open to considerable doubt. The latter is inscribed with the initials "S. C.," but the general character of the painting, and in particular the noticeably hard rendering of the wig (Plate XL), are so unlike Cooper's manner that one can safely say this miniature is not by him. It may well be an old copy of one by Cooper, with whom Butler was on terms of friendship, and at one time studied painting. David des Granges is represented by a limning of *Mary Villiers, Duchess of Richmond and Lenox*, the only daughter of the celebrated Duke of Buckingham (CC 8, signed and dated 1648), whose first husband was Charles, Lord Herbert of Shurland, of whom there are two portraits in the collection (DRB 12 and 22) ; and William Faithorne the Elder, by a water-colour drawing of *Barbara Villiers, Duchess of Cleveland*, after a portrait by Lely (N 10, Plate XLVI). Although very possibly made with a view to engraving like the other, this drawing should be distinguished from that to the waist only, which Pepys saw in Faithorne's house and wanted to buy. Two miniatures are said to be by Richard Gibson the Dwarf, No. Q 1, *Ruperta*, daughter, by Prince Rupert, of Margaret Hughes the actress (N 13), who is said

to have been the first female representative of Desdemona ; and P 22, called *The Duke of Monmouth*. As, however, authentic examples of this artist's work are rare, and these two differ in style from one another as well as from those ascribed to Gibson in the Madresfield Court Collection, the attributions are given with great reserve. On the other hand the small limning of *Henry Cavendish, Earl of Ogle* (R 30 in the catalogue, where it is wrongly called an enamel of the Duke of Monmouth by Boit), appears to resemble very closely another of the Earl of Ogle in the Welbeck Abbey Collection (No. 161), on the backboard ot which is a label inscribed by the second Earl of Oxford (1689-1741), "Henry Cavendishe, Lord Ogle by Gibson." By way of conclusion to this section of the notes, mention may be made of two miniatures in oil by unknown artists, the first called *Major-General Desborough* (O 35), and the second a *Man Unknown* (G 17). The latter in particular is painted with extraordinary vigour, and for skill of draughtsmanship, as well as richness of colour, is surpassed by few other miniatures in this medium (Plate XLIII). The former (Plate XLIV) bears no resemblance to the portrait of General Desborough lent by Miss Disbrowe to the National Portrait Exhibition, 1866 (No. 813). If a Desborough portrait at all, it must represent the younger brother, Samuel, who was one of the early settlers of Guildford, Connecticut, U.S.A., and after his return from there was appointed Keeper of the Great Seal in Scotland (*cf.* N.P.E. 1866 ; No. 822).

THE collection contains a number of portraits by Nicholas Dixon, who succeeded Cooper as King's Limner, some skilfully painted, others merely "tollerable," to use Vertue's epithet. Amongst the former must be classed the *Man Unknown* (O 6, signed and dated 1669), which we reproduce in colour on Plate L ; the *Young Man Unknown*, erroneously called *General Monck* (R 39), which, in view of the style of cravat, must have been painted at about the same period as the first, and therefore cannot represent that general then nearly sixty years old ; *Robert Spencer, Earl of Sunderland, K.G.* (?) (P 13, Plate XLVII), described by the Princess Anne as "the subtellest workingest villain on the face ot the earth" ; and *Sir William Temple*, statesman and poet (P 12), if this is correctly attributed to Dixon. For there is a stiffness of pose about the last-named miniature not usually met with in his work. The portrait of a boy holding a St. Bernard dog (BB 6), which is signed "DM," is attributed to Dixon in the catalogue, and this attribution has behind it the authority of Vertue, who, in connexion with another miniature with a similar signature, suggested that the monogram might stand for "Dixon, the first and last letters." There is, however, little to suggest that artist's hand in the rather rigidly-drawn painting now under notice (Plate XLV) ; moreover, as Mr. Goulding has pointed out, the letters in the monogram are not "D. N.," but "D. M." As a matter of

iconography, it must be added that the portrait is said to be that ot *Henry Fitzroy, Duke of Grafton, K.G.,* the Duchess of Cleveland's second son by Charles II, but it bears no resemblance to the miniature reproduced in Edwards' "Historical Portrait Gallery," pl. xxxv, ii, nor to his portrait by Edward Hawker at Euston Hall.* Of Dixon's miniatures of women, the most noteworthy are Nos. N 22 and Q 17, both *Ladies Unknown*; and Q 2, also called a *Lady Unknown*, but somewhat resembling *Frances Jennings*, the beautiful and sprightly maid-of-honour to the Duchess of York, who, after the death of her first husband, Sir George Hamilton, married the handsome Duke of Tyrconnell (Plate L, *cf.* Pl. LVI). The charm of the expression, the skilful treatment of the hair, and the refined and delicate scheme of colour, combine to render this the most attractive of all Dixon's portraits of women in the collection. Thomas Flatman, who at his best was thought by Vertue to be equal† to Hoskins "senior or junior," is represented by two miniatures—F 12, signed and dated 1661, and F 19, the face in which has been so much damaged in the course of time as to be practically unrecognizable. The former (Plate LIV) is catalogued as a portrait of Sir Henry Vane, but is clearly a self-portrait of the artist, of whom there is another self-portrait, dated 1662, in the Dyce Collection at the Museum (No. D 95). It was, indeed, engraved and published in 1794, under the title of Thomas Flatman, by W. Richardson, in whose possession it then was.

THE collection contains several limnings by unknown artists working in the second half of the seventeenth century, including two superb specimens in oil, No. BB 8, doubtfully said to represent *Andrew Marvell*, the poet of the Commonwealth, and No. DD 5, a *Man Unknown* (Plates XLIII and XLIV). Both were at one time attributed to Francesco Cleyn, a designer employed at the Mortlake Tapestry Works by Sir Francis Crane in the reign of Charles I. But Mr. Dudley Heath pointed out in an article in "The Art Journal" (1907; p. 11) that the latter is signed with the initials "S. F." or "F. S."; and examination ot the former while in the Museum has revealed the same monogram on the right-hand side of the dark background. It has not been possible to identify the artist using this signature, but whoever he was, there can be no doubt as to his consummate skill. The first of the two is a particularly fine painting, and is no less remarkable for the skilful use which the artist has made of the very limited background than for the dignified presentment of the sitter's features. It is, perhaps, significant that the portrait of *Colonel Duckett*, reproduced by Dr. Propert in his

* Reproduced in "Lely and the Stuart Portrait Painters," by C. H. Collins Baker, vol. i, p. 180.
† The superb miniature by Flatman in the Salting Collection formerly called *Sir John Maynard* (No. 4637), is certainly as fine as any limning by Hoskins, and fully justifies the high opinion expressed by Vertue.

"History of the Miniature Art" (p. 78), and evidently by the same hand as the above, should at the time have been attributed to no less an artist than Samuel Cooper.* The initials " P. C." appearing on the charming portrait of a *Little Girl* (DSRC 4, Plate LVI) are similar to those on a miniature of Queen Mary of Modena, formerly in the H. J. Pfungst Collection, which, if a note on the back may be accepted, was painted by Paolo Carandini. This artist was a native of Modena, and is said to have come to this country in Queen Mary's train, but if the Buccleuch miniature is correctly ascribed to him, he must have been here some time previously, for it is dated 1668, and Mary of Modena did not arrive in England until 1673. According to Thieme's "Dictionary of Artists," he was working at Rome in 1650.† Vertue notes that he saw a portrait of *Dorothea, youngest daughter of Richard Cromwell, æt. 4*, 1668, which was signed "P. C." But although the limning now under notice answers to that description in several respects, the writer has not been able to establish any connexion between the two works. It has become clear, however, that there is something wrong in Vertue's record, for, from information kindly furnished by the Rev. T. Cromwell Bush, it appears that Dorothy, the seventh daughter and ninth child, was born in 1660, and was therefore eight in the year in question. Amongst the other miniatures in this section of the collection may be noticed a carefully executed drawing in plumbago of *Charles II*, after Samuel Cooper, by the Scotch artist David Paton (A 9, signed and dated 1669); *John Maitland, Duke of Lauderdale, K.G.* (P 4), which may, perhaps, be by Edmund Ashfield; *Louise Renée de Keroualle, Duchess of Portsmouth* (?) (P 15), somewhat similar in style to the Mary of Modena above mentioned, and perhaps by the same artist rather than by Nicholas Dixon, to whom it is attributed in the catalogue; *Sir Henry Terne* ‡ (Q 6), the naval commander who in 1660 fought in his single vessel against six Spanish ships in an engagement lasting nine hours, possibly by the same hand as the so-called *Duke of Grafton* (BB 6); and *Elizabeth Wriothesley, Countess of Northumberland* (P 6), who married as her second husband

* While these notes were in the press a fourth example, signed with the same monogram and called *Major-General Desborough*, was shown to the writer by its owner, Mr. Holworthy. It is in oil like the others, and no less skilfully painted.
† Signed miniatures by the seventeenth-century artist using these initials are rare. Besides the Buccleuch miniature, the *Mary of Modena*, the *Dorothy Cromwell* and the head of *Lord Roos* (dated 1667), noted by Dallaway, there is one called the *Countess of Warwick* in the Madresfield Court Collection (with the initials conjoined) which bears some resemblance in style to the first of the above, and may very possibly be by the same hand. In the Victoria and Albert Museum Collection there is a limning (the gift of the late Mr. H. J. Pfungst) signed P. C. at the back, and dated MDCLXI (No. P 11–1915), but it is evidently by another artist, as it differs from the others in style, and in the signature, the handwriting being more cursive.
‡ Faithorne engraved a portrait of this officer after a painting by W. Sheppard: an engraving by Harding after the print by Faithorne is to be found in Woodburn's "Gallery of Rare Portraits," 1816, vol. ii.

Ralph, afterwards Duke of, Montagu, by an unknown artist, after a painting thought to be by Comer at Boughton House (Plate LI). This lady was by her first husband, Joscelyn, Earl of Northumberland, the mother of the well-known heiress, Elizabeth Percy, who was married at the tender age of twelve to Henry Cavendish, Earl of Ogle, whose portrait in this collection has been already noted. It may be added that the initials " M. W." appearing on the miniatures of Elizabeth Hamilton, Countess of Grammont, and Miss Wells (?) (p 25 and n 12), are probably those of some eighteenth-century copyist. The same initials, though written somewhat differently, appear on a miniature called Sir Robert Henley in the Madresfield Court Collection, which has been ascribed to J. Michael Wright. This, however, is clearly a copy of the fine portrait of the Earl of Sandwich (?) by Samuel Cooper in the Salting Collection (No. 4628) ; and the writer understands there is no evidence that Wright ever painted in little.

The drawing of the *Duke of Monmouth* as a child (R 18), after Cooper's wonderful unfinished miniature at Windsor, attributed by MacKay to Mrs. Rosse, " probably the wife of James Rosse, an artist who died in 1821," has been thought by Dr. Williamson to be by Mrs. Rosse or Rose, Richard Gibson's daughter, who, according to Vertue, made a special study of Cooper's miniatures, and copied them better than any one else. Dr. Williamson * bases his conclusion partly on the archaic character of the title on the backboard of the frame containing the drawing, which runs as below, and partly on the identity of the handwriting of this endorsement with that on the back of certain miniatures in the Victoria and Albert Museum Collection, which he also thinks are by Mrs. Rosse. It would, however, be questionable whether the copy which we illustrate on Plate LXVIII is vigorous enough to be the work of one who, Vertue says, copied Cooper " to perfection " ; and whether the two handwritings reproduced below are identical :

Duke Montmouth after Mr. Cooper fr. Mrs Rosse.

My Father Rosse

But the question of date has been placed beyond dispute by the discovery that the vellum on which the Montagu House version is painted, is, the writer understands, not older than the nineteenth century. It must, however, be stated that there is no mention of Mrs. James Ross either in Bryan or in Graves, and the only married lady of that surname (whether with or without the "e"), recorded in those authorities as a miniaturist working in the early nineteenth century, is Mrs.

* " History of Portrait Miniatures," vol. i, pp. 50–52. An excellent reproduction of the Windsor miniature will be found in the " Burlington Magazine," vol. ix, p. 367.

H. Ross, the mother of Sir W. C. Ross, R.A. It may be conjectured that **this is a copy of a drawing after Cooper by Mrs. Rosse endorsed by her as above, by an unknown artist of the nineteenth century.**

IN the early years of the eighteenth century the miniature art shared in the decline which attacked portrait-painting generally in this country, but Lawrence Crosse, or Cross as he should be called,* who died in 1724, carried on the tradition of the seventeenth century. Indeed, in many respects his works are comparable with those of his predecessors, notwithstanding the difficulty created by the fashion of wearing full-bottomed wigs, the effect of which must have been to deprive his sitters of much of their individuality. Amongst Cross's miniatures of men in the collection the most noteworthy are a *Garter Knight Unknown*, called *Godert de Ginkell, Earl of Athlone* (P 24), who it cannot be, as the Earl of Athlone was never elected to that order (Plate LVIII) ; *John Holles, Duke of Newcastle, K.G.* (R 37, erroneously called *Henry Fitzroy, Duke of Grafton*) ; and *James Scott, Earl of Dalkeith, K.T.* (R 13, Plate L). The last named was the only surviving son of the Duke of Monmouth, who, it will be remembered, married Anne, Countess of Buccleuch ; and it is a curious, though little known, incident of history that in July or August 1692 " 30 or 40 wyld people " proclaimed him King of Great Britain at the Cross at Sanquhar, in Dumfriesshire.† In fairness to the Earl's memory, it should be added that he was in no way privy to the proclamation. There are two excellent miniatures of women by Cross—*Mary Hyde, Baroness Conway* (Q 22, Plate LVII), who inherited her good looks from her mother, the Court beauty, Henrietta Boyle, Countess of Rochester ; and *Sarah Jennings, Duchess of Marlborough* (?) (N 11). The brightness of the sitter's expression and the skilful painting of the brilliantly-coloured dress against the dark background render the second of these an unusually gay and attractive miniature (Plate LV). Bernard Lens, whose work in general is marked by a certain hardness of effect, is represented by a few characteristic examples, notably the portrait of *Mary, Duchess of Montagu* (R 14), the youngest of the Duke of Marlborough's four daughters, and the *Lady Unknown* (O 11), signed and dated 1720, which may possibly represent another daughter, *Henrietta, Countess of Godolphin*, after 1722 *suo jure Duchess of Malborough* (Plate LIX). Both of these are on ivory, a material of which Lens was the first to make extensive use. To the same artist belongs the so-called portrait of *Mary Queen of Scots* (C 17), after the miniature repaired by Lawrence Cross to the order of the Duke of Hamilton, and in the process beautified out of recognition. The por-

* See Mr. Goulding's " Catalogue of the Welbeck Abbey Collection of Miniatures," p. 25.
† The writer is indebted to Mr. Charles Scott for this information. The incident is related in Sir William Fraser's " Scotts of Buccleuch," and is based on an entry in an old memorandum book in the charter-room at Dalkeith House.

trait of that "hollow-looked" man, *Matthew Prior* (Q 15), represented in a reddish gown with brilliant blue lining over a rich brown coat, is attributed to Bernard Lens in the catalogue, but in its brightness of tone is very reminiscent of the work of Christian Richter, who imparted to his miniatures the strong colours, for which he acquired a taste as the result of his study of Michael Dahl. The portrait of the *Duke of Marlborough* (o 19, signed and dated 1714), is a magnificent example of Richter's skill (Plate LXI); and to Richter may also, perhaps, be attributed No. F 8, *Oliver Cromwell*, after Samuel Cooper. The Swiss artists, Benjamin Arlaud and Jacques Antoine Arlaud, both of whom worked for a time in this country, are represented in the collection, the latter by a portrait of *Charles Edward Stuart* (L 18), the former by a fine head of the *Duke of Marlborough, K.G.* (o 4, where it is wrongly given to Dixon), and by two of *Prince Eugène of Savoy* (Plate LXIII), the general who fought with Marlborough against Louis XIV in the Low Countries in the War of Succession (J 4, M 24). Similar pairs of portraits of these two commanders are at Belvoir Castle and at Welbeck Abbey, in the catalogue of which collection (pp. 116, 117) will be found the grounds for attributing them to Benjamin Arlaud. A second miniature, that of *James II* (L 11), is ascribed to J. A. Arlaud by MacKay, but it has little in common with such specimens of Arlaud's work as the writer has met with. The brass case containing it is engraved at the back "Par Artaud"; and, as the technique suggests that this miniature is by an artist working at the end rather than the beginning of the eighteenth century, it should, perhaps, be given to François Artaud, a miniaturist and antiquarian who lived 1767-1838. It has not been possible to identify the head of John, Duke of Montagu, when young, and the Duke of Marlborough by J. A. Arlaud, which, Walpole says, the Duchess of Montagu possessed (see above, p. 1), unless, perhaps, he had in mind the *Duke of Marlborough* by Benjamin Arland, above mentioned, and that of *John, Duke of Montagu*, when young (J 3), which is certainly of foreign origin and dates from the early years of the eighteenth century.

Andrew Benjamin Lens, the son of Bernard Lens, who flourished about the middle of the century, is represented by a single work, the portrait of *Alexander Pope* (Q 27, from the Strawberry Hill Collection), executed very much in his father's manner. But very few other miniaturists of this period, and none of the great names of the second half of the century, are to be met with in the collection. A portrait of *James Francis Edward Stuart* (L 23, Plate LXIII) is signed "R. S.," which may stand for Sir Robert Strange, the engraver, who was "out" in the '45, and, according to Dr. Propert, painted miniatures chiefly connected with the Stuart family. The portrait of a *Lady Unknown* (H 9) is a characteristic example of the work of Gervase Spencer; and there is one miniature by Ozias Humphry, R.A., *Mary Panton, Duchess of Ancaster*, Mistress

of the Robes to Queen Charlotte, and a Leader of Fashion (H 23, signed and dated 1770). As, however, the Duchess of Ancaster was forty when this miniature was painted, and the lady represented scarcely appears to be more than twenty-six, some degree of doubt as to the correctness of the title is inevitable unless we suppose that Humphry wished to flatter his sitter. The miniature (Plate LXIV) may be compared with an engraving of the Duchess by McArdell, after a painting by Hudson done in 1757, and with a portrait by Sir Joshua Reynolds, (reproduced respectively in Smith, " British Mezzotinto Portraits," p. 836, and Graves," Engravings from the Works of Sir Joshua Reynolds, P.R.A.," Vol. II (i), pl. 9).

BUT if the art of limning lacked inspiration during the earlier part of the eighteenth century, that of painting in enamel enjoyed a period of strength and vigour. True, the high level attained by Petitot* in the preceding century may not have been reached again, though Zincke was sometimes, or, as Walpole puts it, " once or twice, but once or twice," not far behind him (cf., for instance, the portrait of *Philip, Duke of Orleans*, in the Madresfield Court Collection). But the numerous examples now to be seen in the Museum clearly show that within the limits of the process the efforts of the various enamellists met with no small measure of success. The Buccleuch Collection contains three signed examples, by Charles Boit, during whose period of office as painter to the Queen the title was changed from that of Limner to Enameller. These are the portraits of *Peter the Great* (DSRB 9, Plate LXV), a work of great refinement, *Admiral George Churchill*, a younger brother of the Duke of Marlborough (O 22, Plate LXVI), and *Queen Anne* (L 6). The second of these was formerly in the possession of Horace Walpole, who states (" Description of the Villa," p. 474) that it belonged to the Admiral's niece, Mrs. Dunch. She was the younger daughter of the well-known Arabella Churchill by Charles Godfrey, whom she married after her intimacy with the Duke of York.

Christian Friedrich Zincke, who studied under Boit, is represented by numerous specimens, three of which are signed—*Queen Anne* (L 2); another called Queen Anne, but dated a year after her death and bearing no resemblance to her (L 13, Plate LXVI) ; and *James Brydges, Duke of Chandos* (O 15), well known for his magnificent

* Jean Petitot was in England between the years 1635-45, and owed much of his skill to the knowledge acquired in this country. For he received instruction in drawing from Van Dyck, and in the chemistry of pigments from Sir Theodore de Mayerne, the King's Physician and the leading chemist of the day. But while here Petitot worked principally for King Charles I, and his English enamels are far less numerous than those painted in France. In the Buccleuch Collection there are no enamels belonging to the earlier period, but of the second there are several important examples, notably the portraits of King Louis XIV, and of his brother Philip, in the lids of two snuff-boxes (WDRB 9 and 7), the latter of which at one time belonged to King George IV.

house at Cannons, where Handel spent two years and produced his first English oratorio, "Esther." Of the other enamels by Zincke there may be noticed *Catherine Hyde, Duchess of Queensberry* (o 13), no less famous for her beauty and kindness, than for her wit and eccentricity; *Sir Robert Walpole, K.G.* (o 25); *John, Duke of Montagu, K.G.* (o 1), and his Duchess, *Mary Churchill* (o 41), the latter (after a painting by Kneller at Boughton House) in its original frame with her coat-of-arms at the back; her sister, *Elizabeth, Countess of Bridgewater* (o 5); three enamels (o 20, 28 and 30), evidently representing the same lady as that in the limning by Bernard Lens above mentioned (o 11), who we have suggested may be Henrietta, Countess of Godolphin; and o 18, a *Lady Unknown* (Plate LIX), who may be identified as *Anne Churchill, Countess of Sunderland*. *Horace Walpole* when young (o 31) is by William Prewett, signed and dated 1735; a *Lady Unknown* (H 14) is by the Swiss enamellist, Jean André Rouquet, who worked for many years in England in the first half of the eighteenth century; and a somewhat doubtful portrait of *Admiral Byng* (H 17) is by Gervase Spencer, signed and dated 1752.

One of the most attractive enamels in the collection is that of *George Washington* (H 13), which we reproduce in colour on Plate LXIV. Not only is the colour-scheme particularly harmonious, but the drawing is marked by a breadth of treatment that is somewhat unusual in work of this kind. The portrait is, perhaps, a composite one inspired as regards the head by the well-known paintings of Washington by Gilbert Stuart, and one cannot fail to notice the set look of the upper lip, due, it is said, to an ill-fitting set of false teeth with which Washington had been supplied just at the time when he sat to Stuart. This charming work is signed "W. P.," and is ascribed to William Prewett in the catalogue, but the correctness of the attribution would appear to be open to question. Not only does it differ materially in style from the *Horace Walpole* above mentioned (and from another signed example by Prewett in the Museum, No. 915-'68), but Washington, born in 1732, is represented at least in his sixtieth year (Stuart's portraits were painted in 1795-6), whereas the *Horace Walpole* is dated 1735. If, therefore, they are both by the same hand, Prewett must have had an unusually long artistic career. To this artist too is attributed in the catalogue a miniature (R 34) called *Eleanor Gwyn*, which is also signed "W. P." (Plate LIII), but both the attribution and the title are in error. For the limning dates from the seventeenth century, and is evidently after Lely's painting, now in the National Portrait Gallery, perhaps representing the rival actress, Mary Davis, of the "Duke's" company, who danced her way into the public favour, and for a year or two held the fancy of the King.

H. A. KENNEDY.

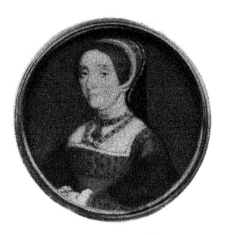

QUEEN CATHERINE HOWARD
BY HANS HOLBEIN

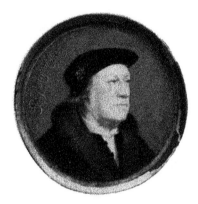

GEORGE NEVILL
BARON ABERGAVENNY, K G
BY HANS HOLBEIN

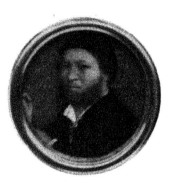

HANS HOLBEIN, IN HIS 45TH YEAR
DATED 1543
BY HIMSELF

PLATE II

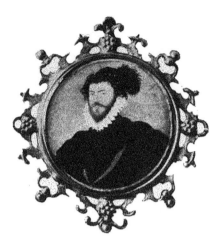

NICHOLAS HILLIARD IN HIS 37TH YEAR
DATED 1574
BY HIMSELF

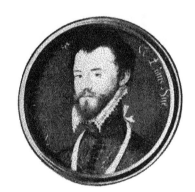

CALLED EDWARD COURTENAY, EARL OF DEVON
DATED 1572
BY NICHOLAS HILLIARD

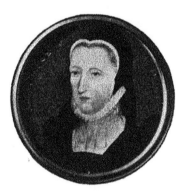

LADY UNKNOWN IN HER 52ND YEAR
DATED 1572
BY NICHOLAS HILLIARD

PLATE III

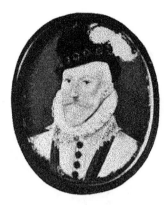

CHIEF HENRY CAREY, BARON HUNSDON, K G.
DATED 1605
BY NICHOLAS HILLIARD

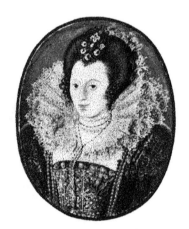

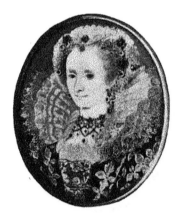

QUEEN ELIZABETH (?)
BY NICHOLAS HILLIARD

QUEEN ELIZABETH (?)
BY NICHOLAS HILLIARD

PLATE IV

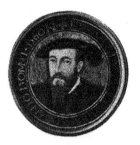

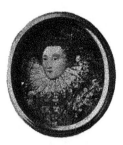

EDWARD SEYMOUR
DUKE OF SOMERSET, K G. (?)
DATED 1560
ATTRIBUTED TO NICHOLAS HILLIARD

QUEEN ELIZABETH
BY NICHOLAS HILLIARD

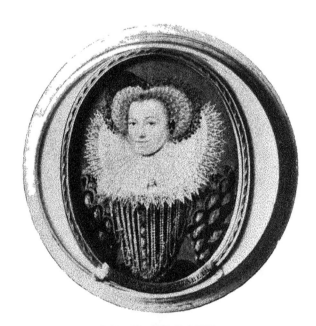

CALLED PRINCESS ELIZABETH
BY NICHOLAS HILLIARD

PLATE V

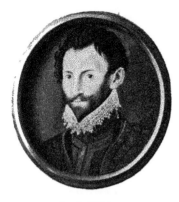

SIR HORATIO **PALAVICINO** IN HIS 52ND YEAR
DATED 1584
ARTIST UNKNOWN

SIR FRANCIS DRAKE IN HIS 42ND YEAR
DATED 1581
ARTIST UNKNOWN

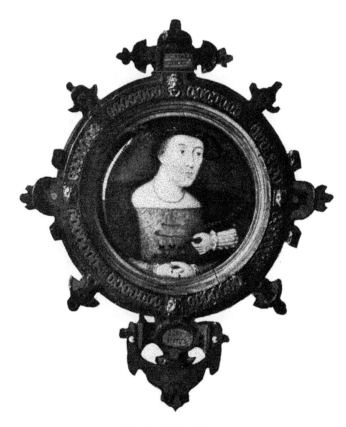

CALLED KING HENRY VII
FRENCH SCHOOL

PLATE VI

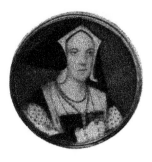

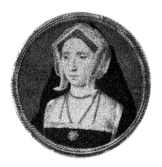

MARGARET WOTTON
MARCHIONESS OF DORSET
ATTRIBUTED TO HANS HOLBEIN

QUEEN JANE SEYMOUR
BY HANS HOLBEIN

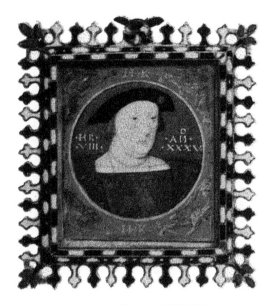

KING HENRY VIII IN HIS 35TH YEAR
ARTIST UNKNOWN

PLATE VII

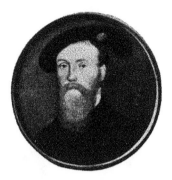

THOMAS, BARON SEYMOUR OF SUDELEY, K G
ARTIST UNKNOWN

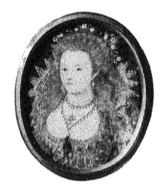

MARY SIDNEY, COUNTESS OF PEMBROKE
BY NICHOLAS HILLIARD

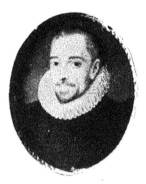

SIR FRANCIS WALSINGHAM (P)
ATTRIBUTED TO JOHN BETTES

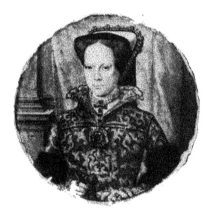

QUEEN MARY I
BY ANTONIO MORE

PLATE VIII

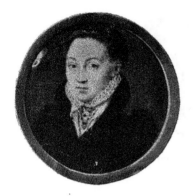

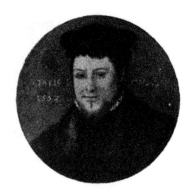

COUNTESS OF HUNTINGDON
ARTIST UNKNOWN

MAN UNKNOWN IN HIS 23RD YEAR
DATED 1553
SIGNED " F. S."

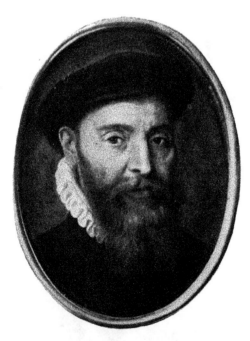

MAN UNKNOWN
DATED 1580
BY JOHN BETTES (?)

PLATE IX

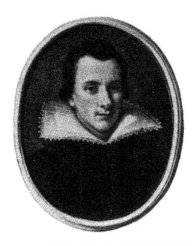

PROBABLY WILLIAM DRUMMOND, OF HAWTHORNDEN
DATED 1611
ARTIST UNKNOWN

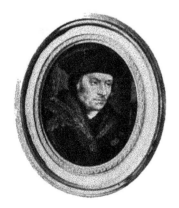

SIR THOMAS MORE
PERHAPS BY HANS HOLBEIN

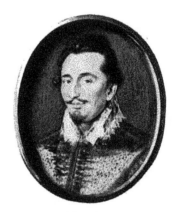

POSSIBLY SIR THOMAS OVERBURY
ARTIST UNKNOWN

PLATE X

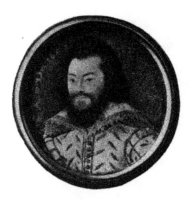

MAN UNKNOWN IN HIS 26TH YEAR
DATED 1603
BY NICHOLAS HILLIARD

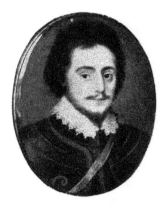

FREDERICK, KING OF BOHEMIA
BY PETER OLIVER

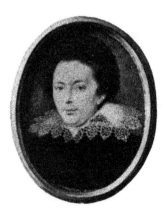

WILLIAM DRUMMOND, OF HAWTHORNDEN (?)
BY ISAAC OLIVER

PLATE XI

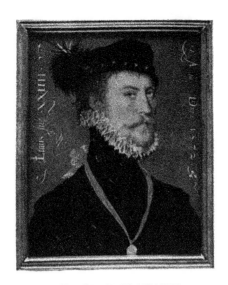

MAN UNKNOWN, IN HIS 24TH YEAR
DATED 1572
BY NICHOLAS HILLIARD

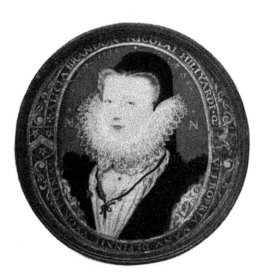

ALICIA BRANDON (MRS. HILLIARD) IN HER 22ND YEAR
DATED 1578
BY NICHOLAS HILLIARD

PLATE XII

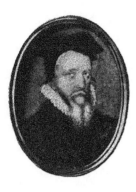

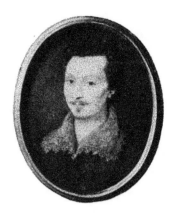

AMBROSE DUDLEY, EARL OF WARWICK, K.G (b)
BY ISAAC OLIVER

SIR PHILIP SIDNEY
BY ISAAC OLIVER

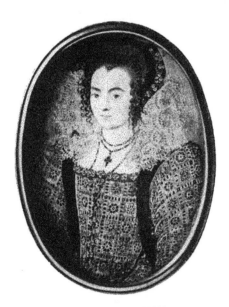

CALLED ANNE CLIFFORD
COUNTESS OF DORSET AND PEMBROKE
BY ISAAC OLIVER

PLATE XIII

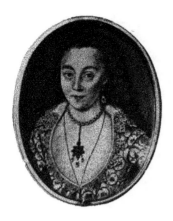

LADY ARABELLA STUART
BY ISAAC OLIVER

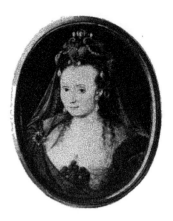

CALLED QUEEN ELIZABETH
BY ISAAC OLIVER

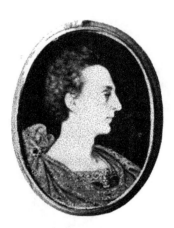

HENRY FREDERICK, PRINCE OF WALES
BY ISAAC OLIVER

PLATE XIV

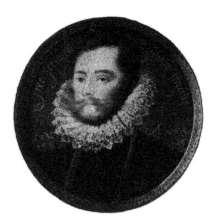

SIR GEORGE CAREY IN HIS 51st YEAR
DATED 1581
BY ISAAC OLIVER

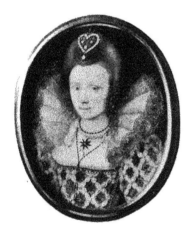

CALLED FRANCES WALSINGHAM
COUNTESS OF ESSEX
BY ISAAC OLIVER

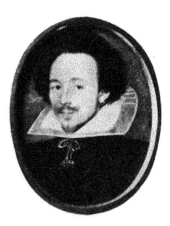

EDWARD, BARON HERBERT
OF CHERBURY
BY ISAAC OLIVER

PLATE XV

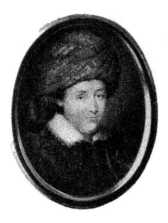

SIR ROBERT SHIRLEY
BY PETER OLIVER

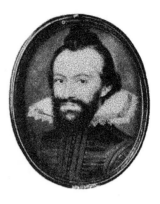

CALLED SIR EDWARD OSBORNE
PROBABLY BY PETER OLIVER

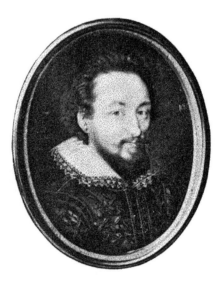

THOMAS, VISCOUNT HOWARD OF BINDON, K G.
PROBABLY BY PETER OLIVER

PLATE XVI

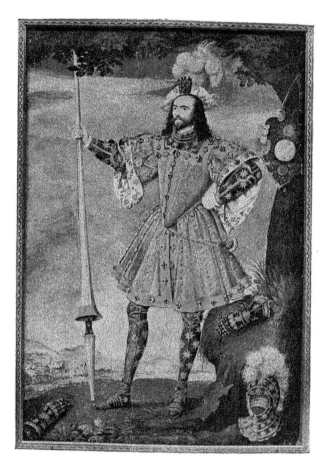

GEORGE CLIFFORD, EARL OF CUMBERLAND, K.G.
IN THE COSTUME OF THE QUEEN'S CHAMPION
BY NICHOLAS HILLIARD

PLATE XVII

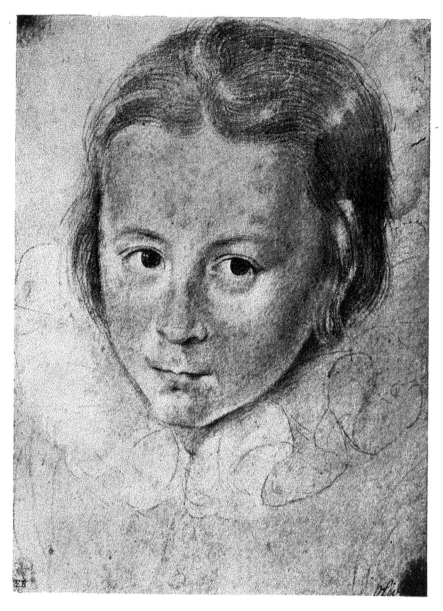

HENRY FREDERICK, PRINCE OF WALES
BY ISAAC OLIVER (P)

PLATE XVIII

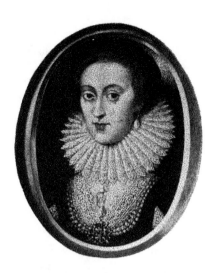

ELIZABETH, QUEEN OF BOHEMIA
ARTIST UNKNOWN

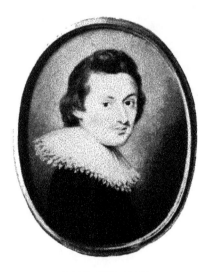

CALLED PETER OLIVER
BY HIMSELF

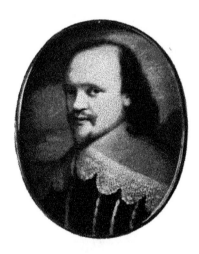

SIR KENELM DIGBY
BY PETER OLIVER

PLATE XIX

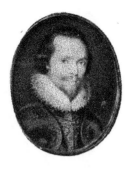

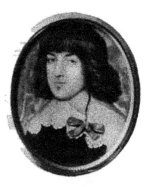

GEORGE VILLIERS
DUKE OF BUCKINGHAM, K.G.
BY PETER OLIVER

CHARLES LOUIS
COUNT PALATINE
PROBABLY BY ALEXANDER-COOPER

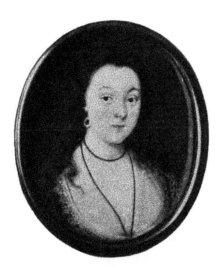

LADY ARABELLA STUART (P)
BY PETER OLIVER

PLATE XX

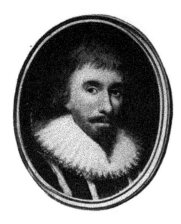

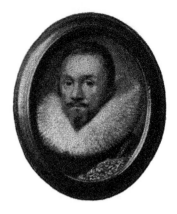

MAN UNKNOWN
ARTIST UNKNOWN

THOMAS, BARON COVENTRY
PERHAPS BY CORNELIUS JOHNSON

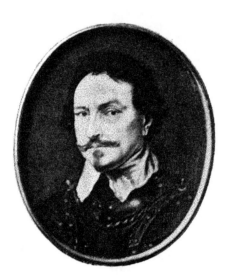

THOMAS WENTWORTH, EARL OF STRAFFORD
AFTER VAN DYCK. ARTIST UNKNOWN

PLATE XXI

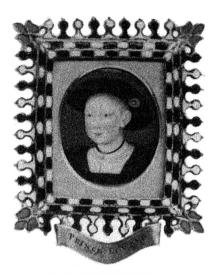

CALLED KING EDWARD VI
ARTIST UNKNOWN

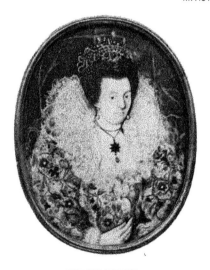

FRANCES HOWARD
DUCHESS OF RICHMOND AND LENOX
BY NICHOLAS HILLIARD

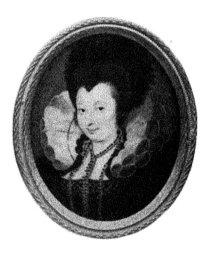

CATHERINE KNEVETT
COUNTESS OF SUFFOLK
BY NICHOLAS HILLIARD

PLATE XXII

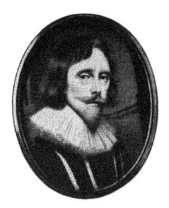

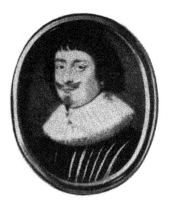

HENRY CAREY, EARL OF MONMOUTH (?)
ARTIST UNKNOWN

HENRY RICH, EARL OF HOLLAND, K G.
BY JOHN HOSKINS THE YOUNGER

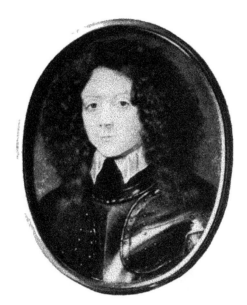

EDWARD MONTAGU
BY JOHN HOSKINS THE YOUNGER

PLATE XXIII

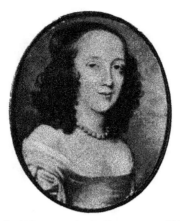

MARY CROMWELL. COUNTESS OF FAUCONBERG (?)
PROBABLY BY JOHN HOSKINS THE YOUNGER

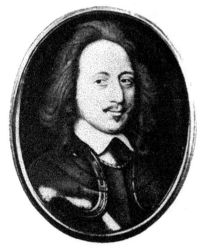

CALLED MONTAGU BERTIE, EARL OF LINDSEY, K.G
DATED 1650
BY JOHN HOSKINS THE YOUNGER

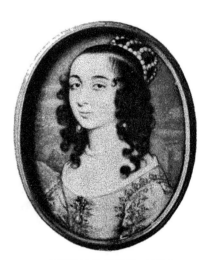

CALLED LADY ISABELLA SCOTT
BY JOHN HOSKINS THE YOUNGER

PLATE XXIV

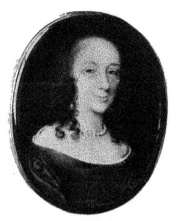

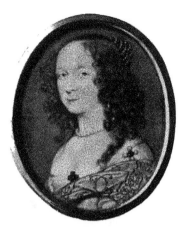

ANNE RICH, LADY BARRINGTON (?)
DATED 1653
BY JOHN HOSKINS THE YOUNGER

CALLED PRINCESS MARY
DATED 1644
BY JOHN HOSKINS THE YOUNGER

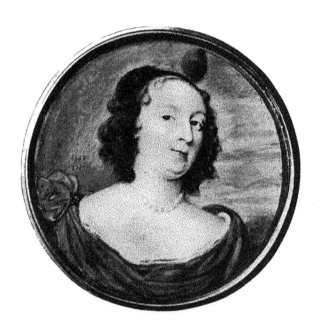

CALLED RACHEL DE RUVIGNY, COUNTESS OF SOUTHAMPTON
DATED 1648
BY JOHN HOSKINS THE YOUNGER

PLATE XXV

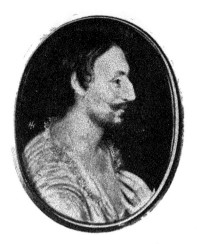

JOHN HOSKINS THE ELDER (?)
BY HIMSELF

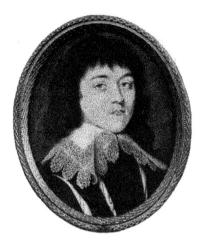

JOHN TUFTON, EARL OF THANET
BY JOHN HOSKINS THE ELDER

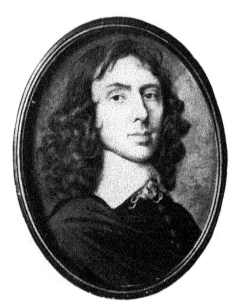

PROBABLY JOHN HOSKINS THE YOUNGER
DATED 1656
BY HIMSELF

PLATE XXVI

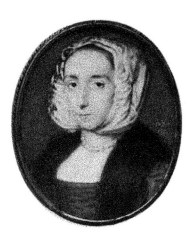

CALLED ELIZABETH VERNON
COUNTESS OF SOUTHAMPTON
DATED 1650
BY JOHN HOSKINS THE YOUNGER

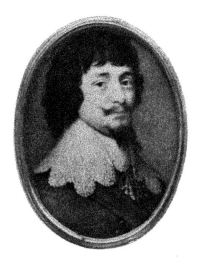

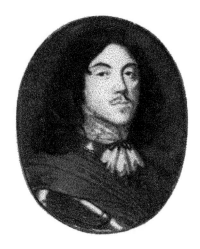

FREDERICK, KING OF BOHEMIA
BY JOHN HOSKINS THE YOUNGER

GENERAL DAVISON
DATED 1646
BY JOHN HOSKINS THE YOUNGER

PLATE XXVII

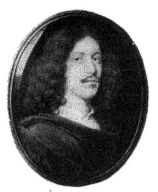

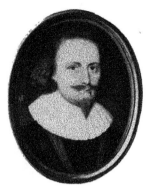

SIR JOHN SUCKLING (?)
BY JOHN HOSKINS THE YOUNGER

ROBERT CARR, EARL OF SOMERSET, K.G.
BY JOHN HOSKINS THE ELDER

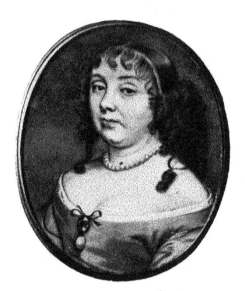

CALLED CHARLOTTE DE LA TRÉMOUÏLLE
COUNTESS OF DERBY
DATED 1671
BY SAMUEL COOPER

PLATE XXVIII

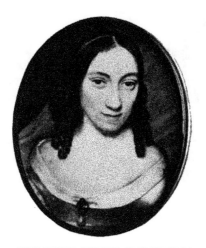

MARY FAIRFAX, DUCHESS OF BUCKINGHAM
BY SAMUEL COOPER

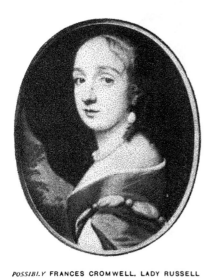

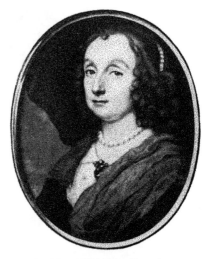

POSSIBLY FRANCES CROMWELL, LADY RUSSELL
DATED 1653
BY SAMUEL COOPER

ELIZABETH BOURCHIER, MRS. CROMWELL
DATED 1651
BY SAMUEL COOPER

PLATE XXIX

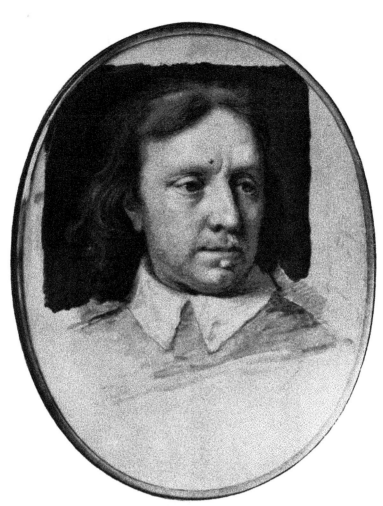

OLIVER CROMWELL
BY SAMUEL COOPER
(Enlarged to about twice the size of the original)

PLATE XXX

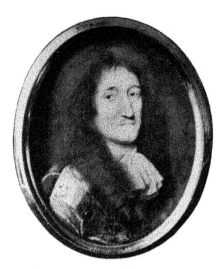

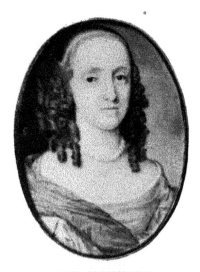

PRINCE RUPERT, COUNT PALATINE. K G
BY SAMUEL COOPER

MARY. PRINCESS ROYAL
BY SAMUEL COOPER

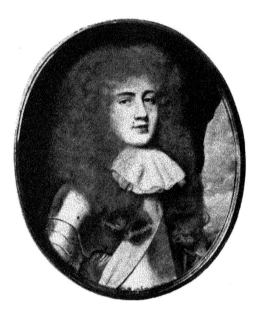

JAMES SCOTT. DUKE OF MONMOUTH AND BUCCLEUCH. K G
DATED 1667
BY SAMUEL COOPER

PLATE XXXI

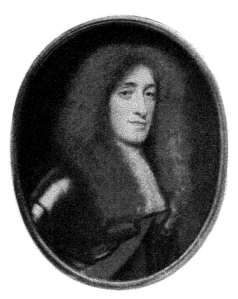

KING JAMES II, WHEN DUKE OF YORK
DATED 167—
BY SAMUEL CCOPER

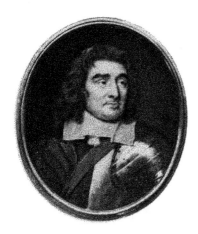

GEORGE MONCK, DUKE OF ALBEMARLE, K.G.
BY SAMUEL COOPER

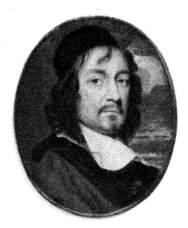

SIR JOHN MAYNARD (p)
BY SAMUEL COOPER

PLATE XXXII

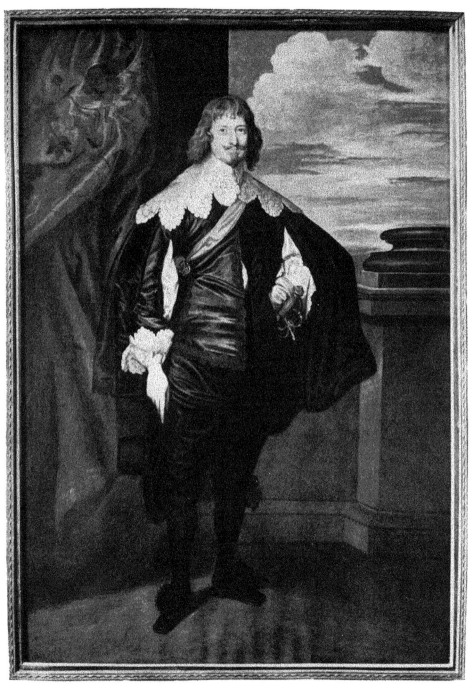

WILLIAM CAVENDISH, DUKE OF NEWCASTLE, K.G.
BY SAMUEL COOPER, AFTER VAN DYCK

PLATE XXXIII

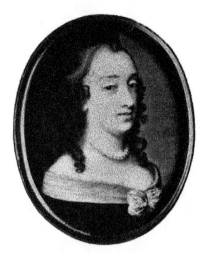

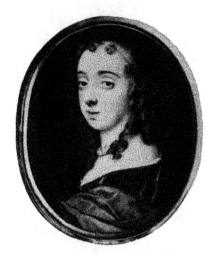

PROBABLY DOROTHY SIDNEY
COUNTESS OF SUNDERLAND
BY SAMUEL COOPER

LADY UNKNOWN
DATED 1655
BY SAMUEL COOPER

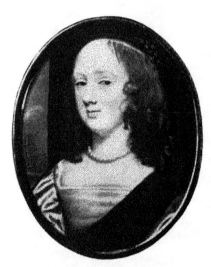

CALLED ELIZABETH VERNON, COUNTESS OF SOUTHAMPTON
DATED 1647
BY SAMUEL COOPER

PLATE XXXIV

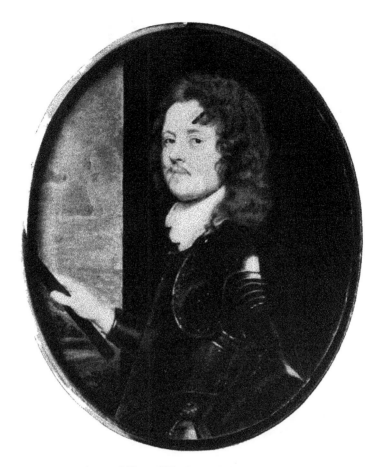

JOHN, BARON BELASYSE OF WORLABY
DATED 1646
BY SAMUEL COOPER

PLATE XXXV

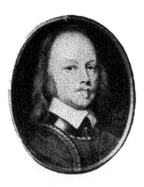

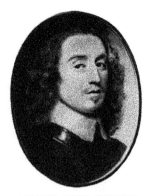

SIR ADRIAN SCROPE
DATED 1650
BY SAMUEL COOPER

PROBABLY HENRY CROMWELL
BY SAMUEL COOPER

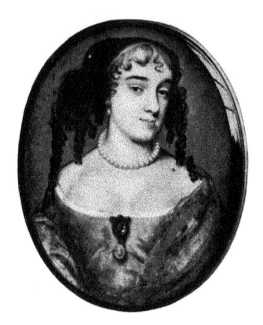

PROBABLY MARGARET BROOKE, LADY DENHAM
BY SAMUEL COOPER

PLATE XXXVI

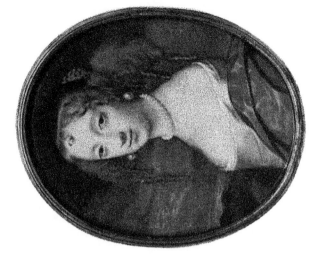

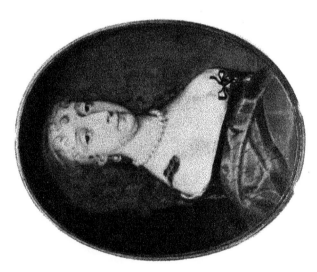

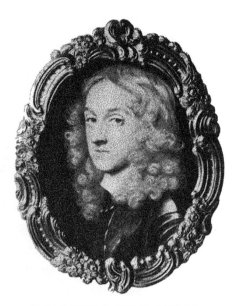

THOMAS OSBORNE, DUKE OF LEEDS, K G
POSSIBLY BY SAMUEL COOPER

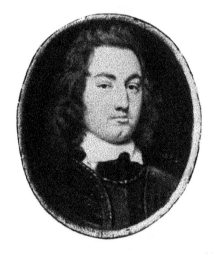

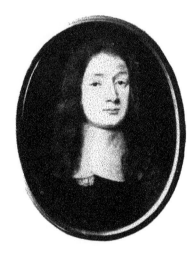

HORATIO, VISCOUNT TOWNSHEND OF RAYNHAM (?)
DATED 1652
BY SAMUEL COOPER

CALLED JOHN MILTON
BY SAMUEL COOPER

PLATE XXXVIII

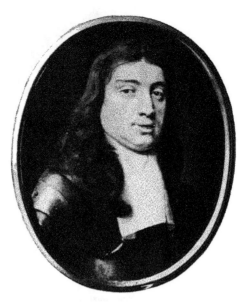

CALLED GEORGE MONCK, DUKE OF ALBEMARLE, K G
BY SAMUEL COOPER

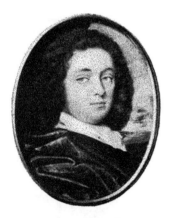

THOMAS OTWAY (?)
ARTIST UNKNOWN

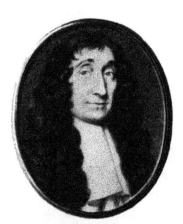

EDMUND WALLER (?)
ATTRIBUTED TO SAMUEL COOPER

PLATE XXXIX

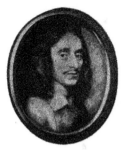

CALLED JOHN OLDHAM
BY JOHN HOSKINS THE YOUNGER

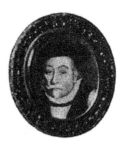

WILLIAM LAUD
ARCHBISHOP OF CANTERBURY
ARTIST UNKNOWN

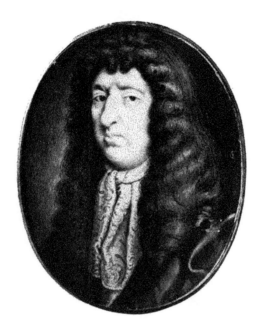

SAMUEL BUTLER
ATTRIBUTED TO SAMUEL COOPER

PLATE XL

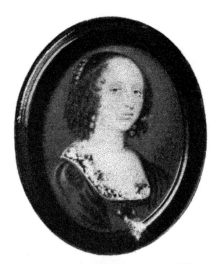

MARY VILLIERS, DUCHESS OF RICHMOND AND LENOX
DATED 1648
BY DAVID DES GRANGES

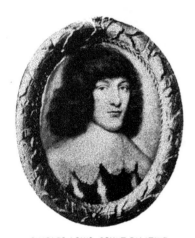

CHARLES LOUIS, COUNT PALATINE
BY ALEXANDER COOPER

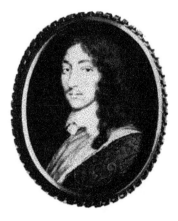

GEORGE GORING, EARL OF NORWICH (?)
ARTIST UNKNOWN

PLATE XLI

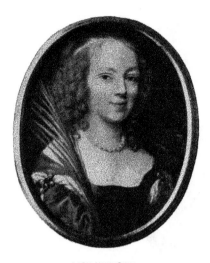

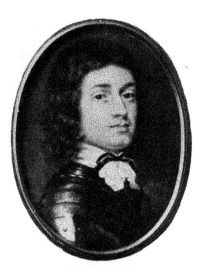

LADY UNKNOWN
REPRESENTED AS 'S.' CATHERINE.
ARTIST UNKNOWN

CHARLES LENOX
DUKE OF RICHMOND AND LENOX, K G (?)
ARTIST UNKNOWN

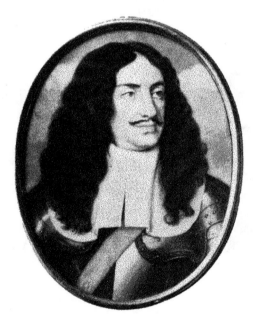

KING CHARLES II
ATTRIBUTED TO SAMUEL COOPER

PLATE XLII

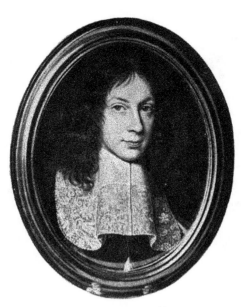

ANDREW MARVELL (?)
SIGNED " F. S."

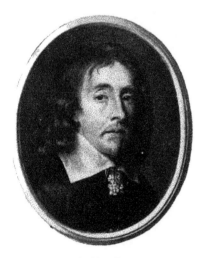

MAN UNKNOWN
ARTIST UNKNOWN

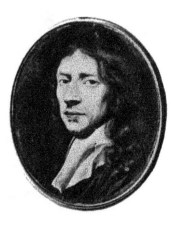

POSSIBLY SIR JOSEPH WILLIAMSON, P.R.S.
ARTIST UNKNOWN

PLATE XLIII

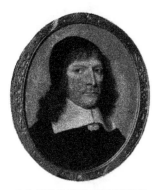

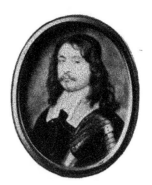

PROBABLY SAMUEL DESBOROUGH
ARTIST UNKNOWN

JAMES GRAHAM
MARQUESS OF MONTROSE (?)
BY SAMUEL COOPER

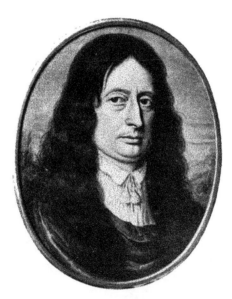

MAN UNKNOWN
SIGNED " F. S."

PLATE XLIV

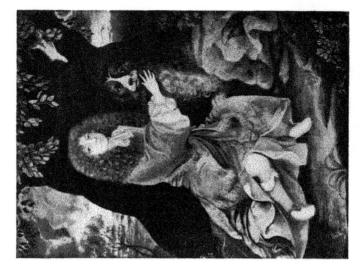

HENRY FITZROY, DUKE OF GRAFTON. K.G.
DATED 1675-6
SIGNED "D. M."

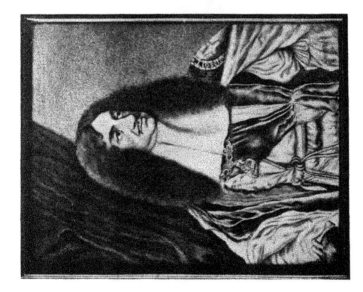

KING CHARLES II
DATED 1669
BY DAVID PATON, AFTER SAMUEL COOPER

PLATE XLV

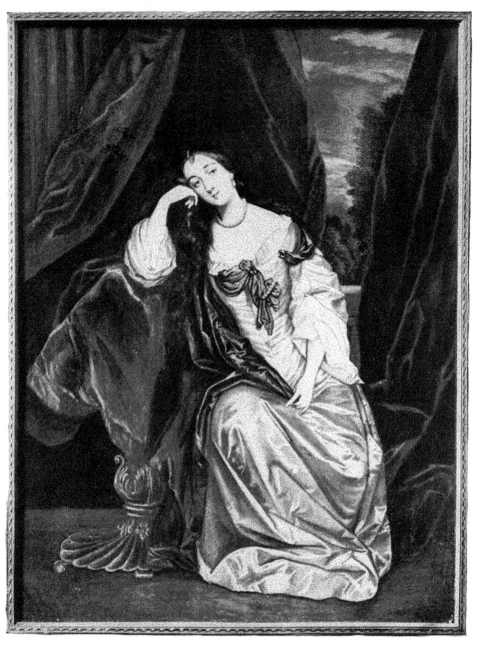

BARBARA VILLIERS, COUNTESS OF CASTELMAINE AND DUCHESS OF CLEVELAND
BY WILLIAM FAITHORNE THE ELDER, AFTER LELY

PLATE XLVI

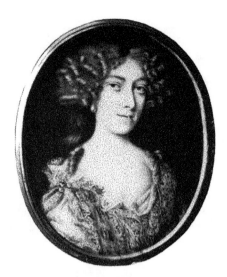

LADY UNKNOWN
BY NICHOLAS DIXON

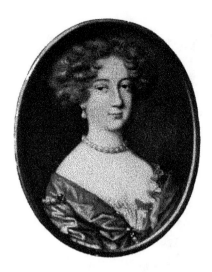

LADY UNKNOWN
BY NICHOLAS DIXON

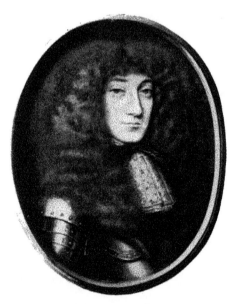

ROBERT SPENCER, EARL OF SUNDERLAND. K G (?)
BY NICHOLAS DIXON

PLATE XLVII

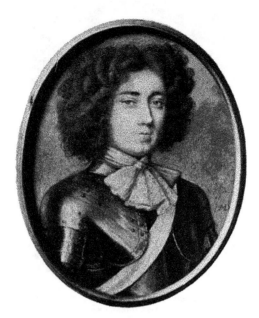

JAMES SCOTT. DUKE OF MONMOUTH AND BUCCLEUCH, K.G.
BY NICHOLAS DIXON

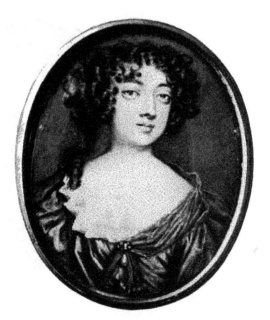

LUCY WALTER
PROFILE BY NICHOLAS DIXON

PLATE XLVIII

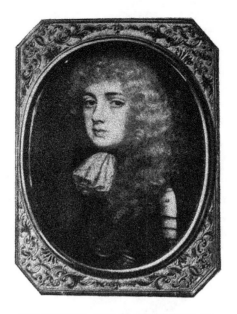

JOHN CHURCHILL, DUKE OF MARLBOROUGH, K G
ARTIST UNKNOWN

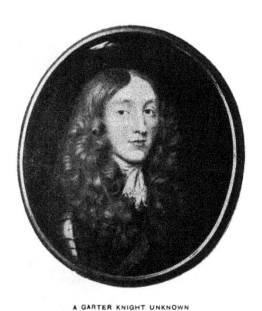

SIR WILLIAM TEMPLE
BY NICHOLAS DIXON (?)

A GARTER KNIGHT UNKNOWN
PERHAPS BY H. BYRNE

PLATE XLIX

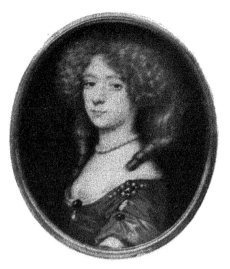

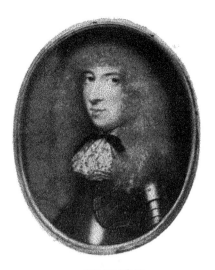

POSSIBLY FRANCES JENNINGS
DUCHESS OF TYRCONNELL
BY NICHOLAS DIXON

MAN UNKNOWN
SIGNED AND DATED 1669
BY NICHOLAS DIXON

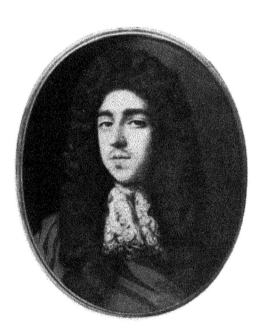

JAMES SCOTT, EARL OF DALKEITH, K.T.
BY LAWRENCE CROSS

PLATE L

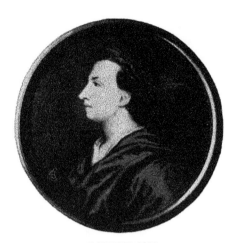

ALEXANDER POFE
BY ANDREW BENJAMIN LENS

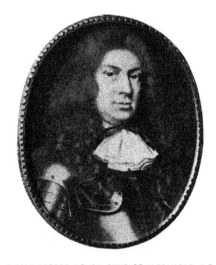

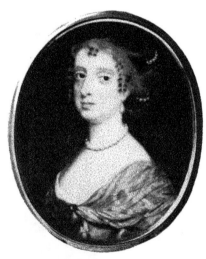

CALLED GEORGE MONCK, DUKE OF ALBEMARLE, K.G.
BY NICHOLAS DIXON

ELIZABETH WRIOTHESLEY, COUNTESS OF NORTHUMBERLA
AFTER CROMER (?) : ARTIST UNKNOWN

PLATE LI

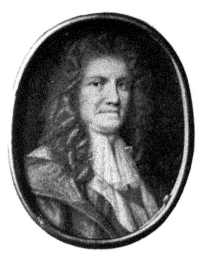

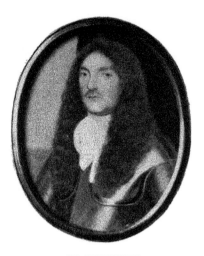

CALLED SAMUEL PEPYS
DATED 1688
BY CHARLES BEALE

SIR HENRY TERNE
ARTIST UNKNOWN

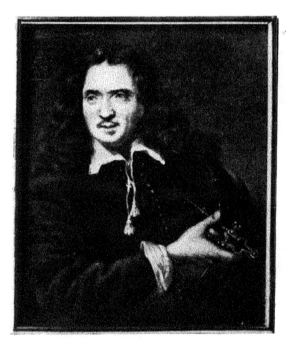

CAIUS GABRIEL CIBBER
PERHAPS BY CHARLES BEALE

PLATE LII

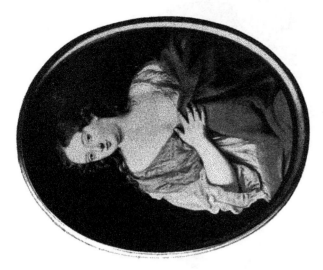

POSSIBLY MARY DAVIS
SIGNED " W. P."

JOHN MAITLAND, DUKE OF LAUDERDALE, K.G.
PERHAPS BY EDMUND ASHFIELD

PLATE LIII

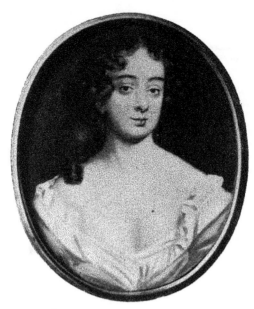

LOUISE, RENÉE DE KEROUALLE, DUCHESS OF PORTSMOUTH (p)
PERHAPS BY PAOLO CARANDINI

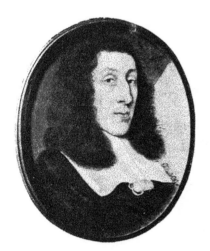

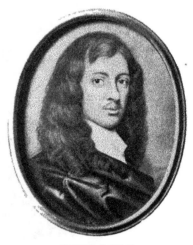

JOHN EVELYN (?)
ARTIST UNKNOWN

THOMAS FLATMAN
DATED 1661
BY HIMSELF

PLATE LIV

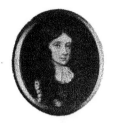

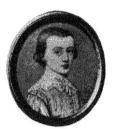

PROBABLY HENRY CAVENDISH
EARL OF OGLE
PERHAPS BY RICHARD GIBSON

CHILD UNKNOWN
BY PENELOPE COTES

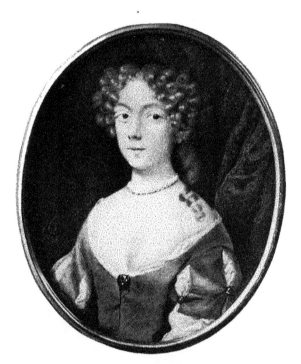

SARAH JENNINGS, DUCHESS OF MARLBOROUGH (?)
BY LAWRENCE CROSS

PLATE LV

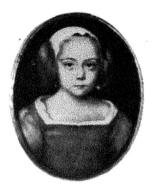

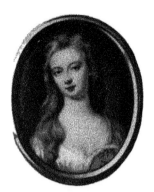

CHILD UNKNOWN
DATED 1668
PERHAPS BY PAOLO CARANDINI

CATHERINE HYDE
DUCHESS OF QUEENSBERRY
BY CHRISTIAN FRIEDRICH ZINCKE

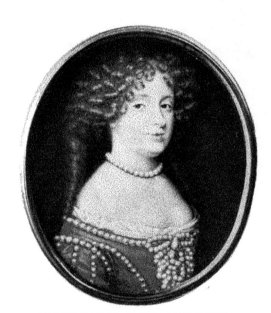

FRANCES JENNINGS, DUCHESS OF TYRCONNELL
ARTIST UNKNOWN

PLATE LVI

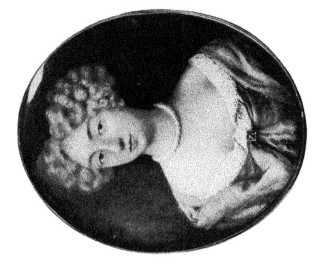

MARY HYDE, BARONESS CONWAY
BY LAWRENCE CROSS

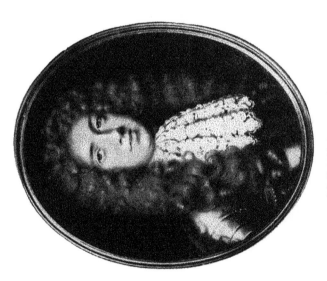

SIR EDWARD SPRAGGE (?)
BY LAWRENCE CROSS

PLATE LVII

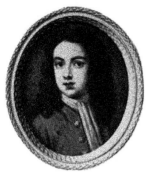

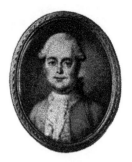

LORD PERCY SEYMOUR
BY BERNARD LENS

EDWARD GIBBON (p)
ARTIST UNKNOWN

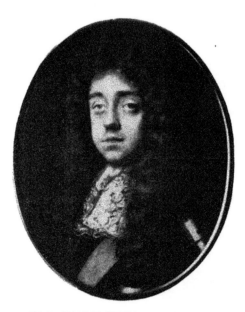

CALLED GODERT DE GINKELL, EARL OF ATHLONE
BY LAWRENCE CROSS

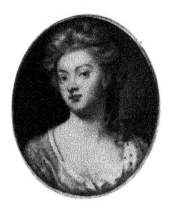

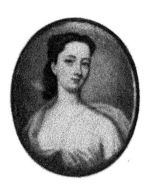

SARAH JENNINGS
DUCHESS OF MARLBOROUGH
ARTIST UNKNOWN

PROBABLY ANNE CHURCHILL
COUNTESS OF SUNDERLAND
BY CHRISTIAN FRIEDRICH ZINCKE

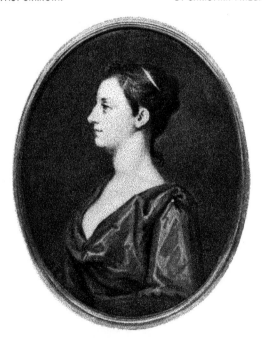

POSSIBLY HENRIETTA CHURCHILL, COUNTESS OF GODOLPHIN
DATED 1720
BY BERNARD LENS

PLATE LIX

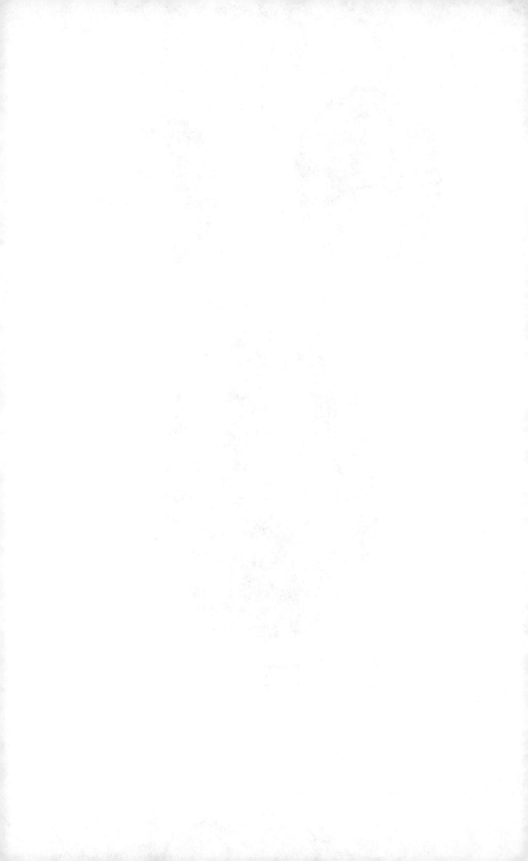

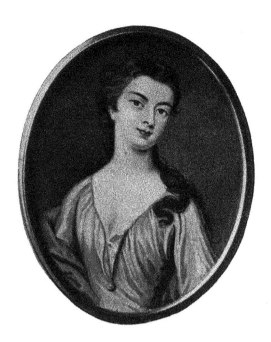

MARY CHURCHILL, DUCHESS OF MONTAGU
BY BERNARD LENS

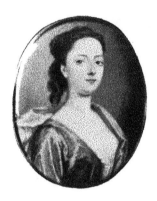

POSSIBLY HENRIETTA CHURCHILL
COUNTESS OF GODOLPHIN
BY CHRISTIAN FRIEDRICH ZINCKE

ELIZABETH CHURCHILL
COUNTESS OF BRIDGEWATER
BY CHRISTIAN FRIEDRICH ZINCKE

PLATE LX

JOHN. DUKE OF MONTAGU, K.G.
BY CHRISTIAN FRIEDRICH ZINCKE

SIR ROBERT WALPOLE
EARL OF ORFORD, K G
BY CHRISTIAN FRIEDRICH ZINCKE

JOHN CHURCHILL, DUKE OF MARLBOROUGH, K.G.
DATED 1714
BY CHRISTIAN RICHTER

PLATE LXI

MATTHEW PRIOR
PERHAPS BY CHRISTIAN RICHTER

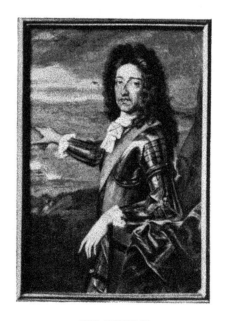

KING WILLIAM III
ARTIST UNKNOWN

PLATE LXII

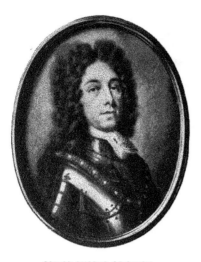

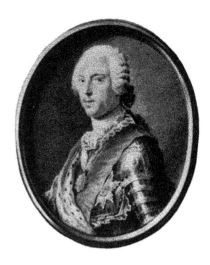

PRINCE EUGENE OF SAVOY
BY BENJAMIN ARLAUD

PRINCE JAMES FRANCIS EDWARD STUART
BY SIR ROBERT STRANGE

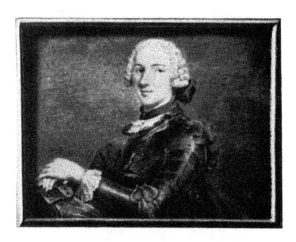

PRINCE CHARLES EDWARD STUART
BY JACQUES ANTOINE ARLAUD

PLATE LXIII

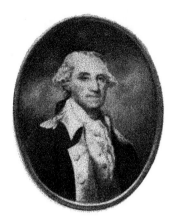

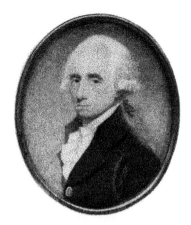

GEORGE WASHINGTON
SIGNED " W P."

WARREN HASTINGS
ARTIST UNKNOWN

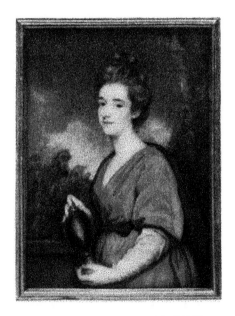

MARY PANTON, DUCHESS OF ANCASTER (?)
DATED 1770
BY OZIAS HUMPHRY, R.A.

PLATE LXIV

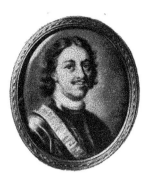

PETER THE GREAT
BY CHARLES BOIT

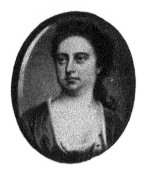

QUEEN ANNE
DATED 1713
BY CHARLES BOIT

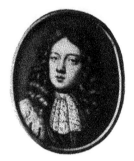

JAMES SCOTT, DUKE OF MONMOUTH
AND BUCCLEUCH, K G.
PERHAPS BY CHARLES BOIT

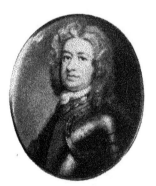

GENERAL MICHAEL RICHARDS
BY CHARLES BOIT

PLATE LXV

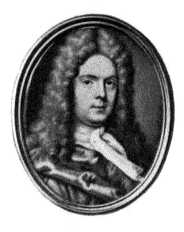

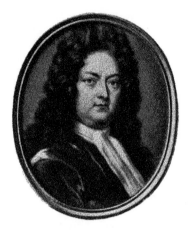

JAMES BRYDGES, DUKE OF CHANDOS
BY CHRISTIAN FRIEDRICH ZINCKE

ADMIRAL GEORGE CHURCHILL
BY CHARLES BOIT

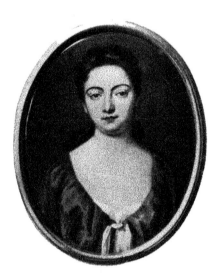

CALLED QUEEN ANNE
DATED 1715
BY CHRISTIAN FRIEDRICH ZINCKE

PLATE LXVI

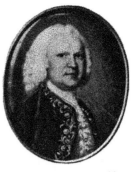

ADMIRAL JOHN BYNG (?)
DATED 1752
BY GERVASE SPENCER

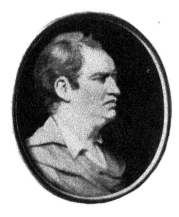

SAMUEL JOHNSON, LL.D
AFTER REYNOLDS, ARTIST UNKNOWN

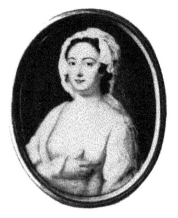

LADY UNKNOWN
BY JEAN ANDRÉ ROUQUET

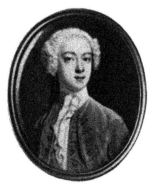

HORACE WALPOLE, EARL OF ORFORD
DATED 1735
BY WILLIAM PREWETT

PLATE LXVII

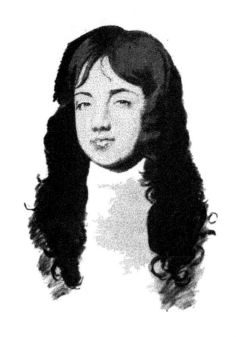

JAMES SCOTT, DUKE OF MONMOUTH AND BUCCLEUCH, K G
AFTER SAMUEL COOPER ARTIST UNKNOWN

PLATE LXVIII

LIST OF MINIATURES IN THE COLLECTION BY ENGLISH ARTISTS. OR BY FOREIGN ARTISTS WORKING IN ENGLAND

The numbers given with each miniature in this list are those in the Catalogue of the Collection compiled by Andrew MacKay and privately printed for the late Duke of Buccleuch in 1896. See Note on page 44 for system of classification.

HANS HOLBEIN (1497 ?–1543)

HANS HOLBEIN (1497 ?–1543), in his 45th year. Signed and dated 1543. G 4

QUEEN CATHERINE HOWARD (1521–1542). C 4
Catalogued as by Isaac Oliver after *Holbein*.

GEORGE NEVILL, Baron Abergavenny, K.G. (1461 ?–1535). AA 12

QUEEN JANE SEYMOUR (1509 ?–1537), called CATHERINE OF ARRAGON. C 5
See above, p. 4, *and Cat. Early Eng. Port.*, B.F.A. Club, 1909, p. 120.

PERHAPS BY HANS HOLBEIN

SIR THOMAS MORE (1478–1535). In oil. DRA 21

ATTRIBUTED TO HANS HOLBEIN

Called KING EDWARD VI (1537–1553). C 12

ATTRIBUTED TO HANS HOLBEIN—contd.

KING HENRY VIII (1491–1547). C 2

MARGARET WOTTON, Marchioness of Dorset, called CATHERINE OF ARRAGON. C 1
See above, p. 3, *and Cat. Early Eng. Port.*, B.F.A. Club, 1909, p. 118.

IN THE STYLE OF, OR AFTER, HANS HOLBEIN

QUEEN CATHERINE OF ARRAGON (1485–1536). C 15

KING HENRY VIII (1491–1547). C 6

KING HENRY VIII. C 8

HANS HOLBEIN (1497 ?–1543), in his 45th year. Signed and dated 1543. In oil. G 3

HANS HOLBEIN. In oil. G 15

NICHOLAS HILLIARD (1537 ?–1619)

ALICIA BRANDON, Mrs. Hilliard, in her 22nd year. Signed and dated 1578. B 5

Called HENRY CAREY, Baron Hunsdon, K.G. (1524 ?–1596). Dated 1605. AA 5
See above, p. 6, footnote.

GEORGE CLIFFORD, Earl of Cumberland, K.G. (1558–1605). DRA 7

Called EDWARD COURTENAY, Earl of Devon (1526 ?–1556). Dated 1572. B 3
See Histor. Portraits 1400–1600, p. 178.

ROBERT DEVEREUX, Earl of Essex, K.G. (1567–1600) ? DRA 4
See Cust. Cat. N.P.G., I, 51.

Called PRINCESS ELIZABETH (1533–1603). C 14

QUEEN ELIZABETH (1533–1603). C 8

QUEEN ELIZABETH. C 10

QUEEN ELIZABETH ? C 18
Catalogued as by *Hilliard* but perhaps by Isaac Oliver.

QUEEN ELIZABETH ? C 20

QUEEN ELIZABETH ? CC 6
See above, p. 8, for a note on the portraits of Queen Elizabeth.

NICHOLAS HILLIARD (1537?–1619), in his 13th year. Signed and dated 1550. AA 15

NICHOLAS HILLIARD, in his 37th year. Dated 1574. B 19

CATHERINE CAREY, Countess of
Nottingham (*d.* 1602/3). DRA 20
But see No. c 22 by Sylvester Harding ; *and*
Burlington Mag., IX, 23.

FRANCES HOWARD, Duchess of
Richmond and Lenox (1576–
1639). DRA 25
Catalogued as by *H*illiard but perhaps by
Isaac Oliver.

CATHERINE KNEVETT, Countess of
Suffolk (1566 ?–1633). B 4
But see No. B 1 by John *H*oskins the elder ;
Portfolio VII, 55 ; *and* Pennant, Journey from
Chester to London, p. 330.

SIR FRANCIS KNOWLES, in his 29th
year. Dated 1585. AA 4

A LADY UNKNOWN, in her 18th
year. Dated 1572. c 9
Catalogued as by Isaac Oliver but more
probably by Hilliard.

A LADY UNKNOWN, in her 19th
year, represented as Lucretia.
Dated 1608. DRA 16

A LADY UNKNOWN, in her 52nd
year. Dated 1572. DSRC 23

A MAN UNKNOWN, in his 45th
year. Dated 1574. B 20

A MAN UNKNOWN, in his 24th
year. Dated 1572. B 21

A MAN UNKNOWN, in his 62nd
year. Dated 1601. DRA 27

A MAN UNKNOWN, in his 28th year.
Dated 1599. DRB 35

Called LUCY PERCY, Countess of
Carlisle (1599 ?–1660). DRA 10
See Law, Vandyck Pictures at Windsor,
p. 69. Catalogued as by Hilliard, but perhaps
by Isaac Oliver.

MARY SIDNEY, Countess of Pem-
broke (1561–1621). DRA 26

Called LADY ARABELLA STUART
(1575–1615). DRA 13
See No. B 36 by Isaac Oliver.

Called EDWARD DE VERE, Earl
of Oxford (1550–1604), in his
30th year. Dated 1588. B 30
See Moule, Illustrious Persons, Pl. 13.

Called HENRY WRIOTHESLEY, Earl
of Southampton, K.G. (1573–
1624), in his 26th year. Dated
1603. B 12
See Walpole Soc. Annual, 1913/14, Pl. 14*a* ;
and Histor. Portraits, 1400–1600, p. 166.

ATTRIBUTED TO NICHOLAS HILLIARD

CATHERINE CAREY, Countess of
Nottingham (*d.* 1602/3). CC 1

ROBERT DUDLEY, Earl of Leicester,
K.G. (1532 ?–1588). DRA 12

RICHARD HILLIARD, in his 58th
year. Dated 1577. DRA 1

KING JAMES I (1566–1625). D 2

A MAN UNKNOWN, in his 30th
year. Dated 1612. B 2

PRINCESS MARY (1605–1607).
Dated 1607. A 27

EDWARD SEYMOUR, Duke of Somer-
set, K.G. (1506 ?–1552/3) ?
Dated 1560. DRA 18
See above, p. 6.

LADY TERESIA SHIRLEY (*d.* 1668).
B 26

LADY ARABELLA STUART (1575–
1615) ? B 39
See No. B 36 by Isaac Oliver ; *and* Walpole
Soc. Annual, 1913/14, Pl. 23, 24.

ESME STUART, Seigneur d'Au-
bigny, and Duke of Lenox
(1542 ?–1583) ? DRA 19
See No. 459, N.P.E. 1866.

*IN THE STYLE OF, OR AFTER, NICHOLAS
HILLIARD*

ESME STUART, Duke of Lenox,
K.G. (1579–1624). DRA 15

EDWARD FIENNES, Earl of Lin-
coln, K.G. (1512–1584/5), in his
59th year. Dated 1565. AA 17
See Cust. Cat. N.P.G., I, 45.

ANNE MORGAN, Baroness Huns-
don (*d.* 1606/7). B 6
Cf. Williamson, History of Portrait Minia-
tures, I, XVII, 17.

SCHOOL OF NICHOLAS HILLIARD

SIR FRANCIS DRAKE (1540 ?–
1596). AA 18
But see Histor. Portraits 1400–1600, p. 84 ;
and Poole, Cat. Oxford Portraits, I, 24.

SIR WALTER RALEIGH (1552 ?–
1618) ? AA 2
See Cust, Cat. N.P.G., I, 51.

OTHER ARTISTS OF THE SIXTEENTH CENTURY

PERHAPS BY *JOHN* BETTES (d. c. 1580)
A MAN UNKNOWN. In oil. Signed
and dated 1580. G 10

ATTRIBU TED TO *JOHN* BETTES
CATHERINE DE BALZAC, Duchess of
Lenox (*d. c.* 1631/2). B 35
Called ROBERT DEVEREUX, Earl of
Essex, K.G. (1567–1600/1). AA 7
See Cust, Cat. N.P G., I. 51.
A MAN UNKNOWN. AA 16
SIR FRANCIS WALSINGHAM
(1530 ?–1590) ? AA 6
See No 258, N.P.E. 1866, *and* Histor.
Portraits 1400-1600, p. 168.

BY *ANTONIO* MORE (1512– c. 1582)
QUEEN MARY I (1516–1558). In
oil. C 8

PERHAPS BY FRANCIS SEGAR
(*fl. c.* 1550–1600)
A MAN UNKNOWN, in his 23rd
year. Signed and dated 1553.
In oil. ' S 21

BY *ARTISTS* UNKNOWN
Possibly NICHOLAS D'ANJOU (*b.*
1518), called HENRY VII (1457–
1509). C 3
See above, p 11.
Called LUCY DAVIES, Countess of
Huntingdon (*d.* 1679). In oil.
 B 11
The style of costume makes this title
impossible.

BY *ARTISTS* *UNKNOWN—contd.*
KING EDWARD VI (1537–1553).
 C 8
KING EDWARD VI. C 13
KING HENRY VII (1457–1509).
 C 8
KING HENRY VIII (1491–1547), in
his 35th year. C 7
A MAN UNKNOWN. In oil. DSRC 8
A MAN UNKNOWN. DSRC 24
SIR HORATIO PALAVICINO (*d.* 1600),
in his 52nd year. Dated 1584.
 S 22
THOMAS, Baron Seymour of Sude-
ley, K.G. (1508 ?–1549). B 14
Catalogued as by Hilliard, *but see* Burling-
ton Mag , VIII, 325.

*PROBABLY AFTER SIXTEEN-
CENTURY MINIATURES*
QUEEN ELIZABETH (1533–1603).
 C 21
A LADY UNKNOWN. R 38
Called MARY, QUEEN OF SCOTS
(1542–1587). C 24

*AFTER SIXTEENTH-CENTURY
PAINTINGS*
EDWARD COURTENAY, Earl of
Devon (1526 ?–1556). B 13
CARDINAL WOLSEY (1475 ?–1530).
 DRA 11

ISAAC OLIVER (*d.* 1617)

CATHERINE CAREY, Countess of
Nottingham (*d.* 1602/3) ? B 24
The style of costume makes this title very
doubtful.
SIR GEORGE CAREY (*d.* 1617), in
his 51st year. Dated 1581.
 AA 14
Perhaps by *Hilliard: see* p. 10 above.
QUEEN CATHERINE OF ARRAGON
(1485–1536). C 8
Called ANNE CLIFFORD, Countess
of Dorset, Pembroke and Mont-
gomery (1590–1676). DRA 22
The style of costume makes this title
impossible.
WILLIAM DRUMMOND of Haw-
thornden (1585–1649) ? Signed.
 B 33
See Caw, Scottish Portraits, II, 28.

AMBROSE DUDLEY, Earl of War-
wick, K.G. (1528 ?–1590) ? B 37
See No. 302, N.P.E., 1866 ; *and cf.* the
portrait of WILLIAM CECIL, Baron Burghley,
in Cust, Cat. N.P.G., I, 49.
Called QUEEN ELIZABETH (1533–
1603). Signed. C 16
See above, p. 8.
FREDERICK V, Elector Palatine,
King of Bohemia (1596–1632).
 DSRB 4
Catalogued as by Peter Oliver but perhaps
by his father.
LUCY HARINGTON, Countess of
Bedford (*d.* 1627). Signed. B 31
HENRY FREDERICK, Prince of
Wales (1594–1612). Signed.
 D 4

31

EDWARD, Baron Herbert of Cherbury (1583–1648). Signed. B 7

Called LUCY PERCY, Countess of Carlisle (1600 ?–1660). Signed. B 8

See Law, Van Dyck Pictures at Windsor, p. 69, *and* A. Edwards, Photographic Histor. Port. Gall., v, 4, where it is called ELIZABETH TALBOT, Countess of Kent (d. 1651).

LADY TERESIA SHIRLEY (*d.* 1668). DRA 2

LADY TERESIA SHIRLEY. DRA 5

SIR PHILIP SIDNEY (1554–1586). DRA 17

LADY ARABELLA STUART (1575–1615). B 36

Called FRANCES WALSINGHAM, Countess of Essex (*b.* 1550) DRA 8

See No. 282, N.P.E. 1866.

HENRY FREDERICK, Prince of Wales (1594–1612). A drawing.

JOHN CLENCH (*d.* 1607). Inscribed I. O., and dated 1583. DRA 3

HENRY FREDERICK, Prince of Wales (1594–1612). D 1

Called JOHN, Baron Harington (1592–1613/4). DRB 3
The style of costume makes this title impossible.

Called MRS. HOLLAND, afterwards Lady Cope (*b. c.* 1568), in her 27th year. B 38
See Propert, History Min. Art, p. 58, *and* Salting Collection, No. 4649.

THOMAS, Lord Wentworth (1525–1583/4) ? B 28
See No. 178, N.P.E. 1866.

PETER OLIVER (1594 ?–1647)

GEORGE CALVERT, Baron Baltimore (1580 ?–1632). Signed. DRB 7

KING CHARLES I (1600–1649). Signed and dated 1630. A 4

HENRY DANVERS, Earl of Danby, K.G. (1573–1643/4). AA 10

SIR KENELM DIGBY (1603–1665). DRB 34

FREDERICK V, Elector Palatine, King of Bohemia (1596–1632). Signed. DSRB 8

FREDERICK V, Elector Palatine, King of Bohemia (1596–1632). Inscribed " I. O. 1624." DSRB 14

WILLIAM, Duke of Hamilton (1616–1651). AA 20

THOMAS, Viscount Howard of Bindon, K.G. (*d.* 1610/11) DRA 23
Catalogued as by Isaac, but perhaps by Peter Oliver.

Called SIR EDWARD OSBORNE (1530–1591). AA 9
The costume is that of the early seventeenth century. Catalogued as by Isaac, but perhaps by Peter Oliver.

SIR ROBERT SHIRLEY (1581–1628). Signed. DRB 27
See above, p. 12.

LADY ARABELLA STUART (1575–1615) ? Signed. DRA 14
See No. B 36 by Isaac Oliver.

Called PETER OLIVER (1594 ?–1647). B 15
See above, p. 12.

GEORGE VILLIERS, Duke of Buckingham, K.G. (1592–1628). Signed. B 29

FRANCIS BACON, Baron Verulam (1561–1626), in his 60th year. Dated 1620. DRA 24

THOMAS WRIOTHESLEY, Earl of Southampton, K.G. (1607–1667). Inscribed P— 167—. DRB 26

THOMAS WRIOTHESLEY, Earl of Southampton, K.G. DRB 30

JOHN HOSKINS THE ELDER (*fl. early* 17*th century*)

See the note on p. 13 above as to the two JOHN HOSKINS.

QUEEN ANNE BOLEYN (1507–1536). C 8

ROBERT CARR, Earl of Somerset, K.G. (1587–1645). Signed. R 12

QUEEN ELIZABETH OF YORK (1465–1503). C 8

KING HENRY VIII (1491–1547). C 25

Called SIR JOHN HARINGTON (1561–1612). Signed. B 40
See No. 410, N.P.E. 1866. The style of costume makes this title impossible.

CATHERINE KNEVETT, Countess of Suffolk (1566–1633) ? Signed. B I
But see B 4 by Nicholas *Hilliard* ; Portfolio VII, 55 ; *and* Pennant, Journey from Chester to London, p. 330.

JOHN HOSKINS THE YOUNGER (*d.* 1664/5 ?)

Called MONTAGU BERTIE, Earl of Lindsey (1608 ?–1666). Signed and dated 1650. DRB 9
See Cust, Cat. N.P.G , I, 125 ; *and* Propert, History Min. Art, p. 78, where the same sitter is called the Earl of Southampton.

RICHARD CROMWELL (1626–1712) ? Signed and dated 1646. F 4
See No. F 13 by Samuel Cooper ; *and* No. 733, N.P.E. 1868.

GENERAL DAVISON. Signed and dated 1646. DRB 8

Probably GEORGE DIGBY, Earl of Bristol, K.G. (1612–1677). Signed and dated 1642. DRB 2
Catalogued as John Digby (1580–1653) : *see* Propert, History Min. Art, p. 76.

FREDERICK V, Elector Palatine, King of Bohemia (1596–1632). DSRB 2

Called QUEEN HENRIETTA MARIA (1609–1669) D 10
See No. D 14.

PHILIP HERBERT, Earl of Pembroke and Montgomery, K.G. (1584–1649/50). DRB I

Probably JOHN HOSKINS the younger. Signed and dated 1656. BB 9
See above, p. 15.

A LADY UNKNOWN. Signed and dated 1645. N 24

Called MARY, Princess Royal (1631–1660). Signed and dated 1644. L 7
See No CC 4 by Samuel Cooper. Catalogued as a daughter of Frederick, King of Bohemia, but labelled Princess Mary.

EDWARD MONTAGU (1635–1665). Signed. P 19

Called JOHN OLDHAM (1653–1683). DRB 29
The costume is of the first half, of the seventeenth century.

JOHN HOSKINS the elder ? Signed. B 23
See above, p. 14.

SIR BENJAMIN RUDYERD, M.P. (1572–1658). Signed. B 17

JOHN TUFTON, Earl of Thanet (1607 ?–1664). Signed. B 10

ANNE RICH, Lady Barrington ? Signed and dated 1653. R 24
See Smith, History Brit. Mezzo. Portraits, VI, 523, *and* No. IB 22 in Beauchamp Collection.

HENRY RICH, Earl of Holland, K.G. (1590–1648/9). Signed. B 34

Called RACHEL DE RUVIGNY, Countess of Southampton (1603–1639/40). Signed and dated 1648. R 15 ·
See Klassiker der Kunst, "Van Dyck," p. 412.

Called LADY ISABELLA SCOTT. Q 8
Lady Isabella Scott died 1747–1748.

JOHN SELDEN (1584–1654). F 15

Called SIR JOHN SUCKLING (1609–1642). Signed and dated 1644.
See No. DRB 28 below. DRB 32

SIR JOHN SUCKLING (1609–1642) ? Signed. DRB 28
See Cust, Cat. N.P.G., I, 81 ; *and* Poole, Cat. Oxford Portraits, I, 25.

Called ELIZABETH VERNON, Countess of Southampton (d. after 1625). Signed and dated 1650. CC 12
See Walpole Soc. Annual, 1913–1914, Pl. 19.

PERHAPS BY JOHN HOSKINS THE YOUNGER

CHARLES, Lord Herbert of Shurland (*c.* 1619–1635/6). Inscribed " I. H." DRB 22
Catalogued as by Isaac Oliver, but inscribed "I. H.," and perhaps by John Hoskins the younger.

ALGERNON SIDNEY (1622–1683). Signed and dated 1659. F 5

CHARLES STANLEY, Earl of Derby (1628/9–1672). AA I
Catalogued as by Samuel Cooper, but perhaps by John Hoskins the younger.

Called SIR HENRY VANE (1613–1662). F 10
See Histor. Portraits 1600–1700, p. 124.

KING CHARLES I (1600–1649). Inscribed "I. H." D 11

KING CHARLES II (1630–1685), when young. A 14

Called JOSEPH HALL, Bishop of Norwich (1574–1656). O 44

See No. 537, N.P.E. 1866.

QUEEN HENRIETTA MARIA (1609–1669). D 13

QUEEN HENRIETTA MARIA D 14

SOPHIA, Electress of Hanover (1630–1714), called MARY, Princess Royal (1631–1660). D 12

See CC 4 by Samuel Cooper; and cf. Cust. Cat. N.P.G., I, 97.

ROBERT PIERREPONT, Earl of Kingston-upon-Hull (1584–1643). DRB 6

MARGARET SACKVILLE, Countess of Thanet (c. 1614–1676). B 27

SAMUEL COOPER (1609–1672)

JOHN, Baron Belasyse (1614–1689). Signed and dated 1646. DRB 25

ELIZABETH BOURCHIER, Mrs. Cromwell (d. 1665). Signed and dated 1651. Cat. p. 154

Probably MARGARET BROOKE, Lady Denham (c. 1647–1666/7), called LADY HEYDON (d. 1642). Signed.

See above, p. 18, footnote. R 36

ELIZABETH BUTLER, Countess of Chesterfield (1640–1665)? Signed and dated 1655. P 2

See No. 966, N P.E. 1866.

WILLIAM CAVENDISH, Duke of Newcastle, K.G. (1592–1676).

 DRB 17

PENELOPE COMPTON, Lady Nicholas? Signed. N 9

The above is the title given in the catalogue, but the strong similarity of this miniature, with its striking features, to the painting of Alice Fanshawe, Lady Bedell, reproduced in Collins, Baker, Lely and Stuart Portrait Painters, vol. i, p. 154, suggests that it may perhaps represent that lady or a member of her family.

Possibly FRANCES CROMWELL, Lady Russell (1638–1720), called ELIZABETH CROMWELL, Mrs. Claypole (1629–1658). Signed and dated 1653. Cat. p. 154

See above, p 16.

ELIZABETH CROMWELL, Mrs. Claypole. Signed and dated 1652.

 Q 4

See above, p. 16.

MARY CROMWELL, Countess of Fauconberg (1636/7–1712/3)?

 DRB 4

See above, p. 17.

OLIVER CROMWELL (1599–1658).

 Cat. p. 153

Possibly HENRY CROMWELL (1628–1674), called RICHARD CROMWELL (1626–1712). F 3

Probably HENRY CROMWELL, called RICHARD CROMWELL. F 20

See above, p. 16, for a discussion of these portraits of Richard Cromwell.

MARY FAIRFAX, Duchess of Buckingham (1638–1704)? Signed and dated 1650. N 18

See No. N 23 below.

MARY FAIRFAX, Duchess of Buckingham (1638–1704). N 23

JAMES GRAHAM, Marquess of Montrose (1612–1650)? DRB 18

See Caw, Scottish Portraits, II, 30, and Morris, "Montrose," frontispiece.

KING JAMES II, when Duke of York (1633–1701). Signed and dated 167–. A 28

KING JAMES II, when Duke of York (1633–1701) R 9

A LADY UNKNOWN. Signed and dated 1655. A 32

Possibly BARBARA VILLIERS, Duchess of Cleveland (1641–1709). Signed. N 5

See above, p 18, footnote.

Possibly MARGARET LESLIE, Lady Balgony (d. 1688), called CHARLOTTE DE LA TRÉMOUILLE, Countess of Derby (1599–1664). Signed and dated 1671. R 4

See above, p 10, and Fraser, Scotts of Buccleuch, vol. i, pl. 4.

A MAN UNKNOWN. Signed and dated 1660. R 1

A MAN UNKNOWN. Signed and dated 1651. BB 2

MARY, Princess Royal of England (1631–1660). Signed. cc 4

MARY, Princess Royal of England? Signed and dated 1647. cc 5

See No. cc 4 above. A replica of this miniature lent by Sir F. Cook for the Burlington Fine Arts Club Exhibition, 1889, was described as a Lady in a Blue Dress: see Pl. xi in the Catalogue of the exhibition.

SIR JOHN MAYNARD (1602-1690)? F 6

See above, p. 17, footnote.

Called JOHN MILTON (1608–1674). Signed. F 9

See above, p. 18, footnote.

Called GEORGE MONCK, Duke of Albemarle, K.G. (1608–1670)? Signed P 18

See above, p. 17

GEORGE MONCK, Duke of Albemarle, K.G. Signed. R 6

THOMAS OSBORNE, Duke of Leeds, K.G. (1631–1712). Inscribed " S. C." 1685. AA 19

CHARLOTTE PASTON, Countess of Yarmouth (d. 1684). Signed. N 2

PRINCE RUPERT, Count Palatine, K.G. (1619–1682). A 31

JAMES SCOTT, Duke of Monmouth and Buccleuch, K.G. (1649–1685), called PHILIP STANHOPE, Earl of Chesterfield (1635–1713/4). Signed and dated 1667. O 2

SIR ADRIAN SCROPE (d. 1667). Signed and dated 1650. AA 11

Probably DOROTHY SIDNEY, Countess of Sunderland (1617–1684). Signed. DRB 16

Catalogued as A Lady Unknown, but probably Lady Dorothy Sidney: see the miniature by Cooper in the Seymour Collection in the V & A. M., and Nos. 576 and 662, N.P.E. 1866.

CHARLES STUART, Duke of Richmond and Lenox, K.G. 1638/9?–1672). Signed and dated 1654. DRB 21

CHARLES STUART, Duke of Richmond and Lenox, K.G. Signed and dated 1655. DRB 31

HORATIO, Viscount Townshend (1630?–1687)? Signed and dated 1652. AA 13

See No. 939, N.P.E. 1866.

NICHOLAS TUFTON, Earl of Thanet (1631–1679). Q 10

Called ELIZABETH VERNON, Countess of Southampton (d. after 1625). Signed and dated 1647. Q 19

See Walpole Soc. Annual, 1913–1914, Pl. 19

ATTRIBUTED TO SAMUEL COOPER

SAMUEL BUTLER (1612–1680). Inscribed " S. C." Q 11

LUCIUS CARY, Viscount Falkland (1610–1643). Inscribed " S. C." DRB 10

KING CHARLES II (1630–1685). A 1

PRINCE CHARLES, PRINCESS MARY and Prince JAMES, Duke of York. A 19

FRANCES TERESA STEWART, Duchess of Richmond and Lenox (1647–1702). Inscribed " S. C. 1654." R 3

Called THOMAS WRIOTHESLEY, Earl of Southampton, K.G. (1607–1667). DRB 24

See Cust, Cat. N.P.G, I, 139.

IN THE STYLE OF, OR AFTER, SAMUEL COOPER

Called MARGARET BROOKE, Lady Denham (1647?–1666/7). N 19

See No. R 36 by Samuel Cooper.

Called ELIZABETH CECIL, Countess of Devonshire (1619–1689). Q 3

See Williamson, History Port. Miniatures, I, xxxiv, 1. Catalogued as by John Hoskins after Van Dyck, but perhaps an old copy after Cooper.

KING CHARLES II (1630–1685). In oil. A 8

KING CHARLES II. A 11

KING CHARLES II. A 20

Called ELIZABETH CROMWELL, Mrs. Claypole (1629–1658). N 6

See No Q 4 by Samuel Cooper The style of head-dress is that of c. 1663–c. 1673.

Probably RICHARD CROMWELL (1626–1712), called HENRY CROMWELL (1628–1674)? F 13

See above, p. 16, and cf. Histor. Portraits 1600–1700, p. 172.

OLIVER CROMWELL (1599–1658).

F I

OLIVER CROMWELL. F II

SIR ROBERT GAYER. R 23

CHARLES, Lord Herbert of Shur-
land (1619–1635/6). DRB 12

A MAN UNKNOWN. A 25

A LADY UNKNOWN. N 4
This miniature is catalogued as by Nicholas
Dixon, but is probably a copy of one by Samuel
Cooper in the Salting Collection (No 4625).

JOHN THURLOE (1616–1668). F 7
Reproduced Histor. Portraits 1600–1700,
p 142; but see Cust, Cat. N.P.G., I, 121, and
No. 812, N.P.E. 1866.

FRANCES WARD, Baroness Dudley
(1611–1697). R 17

OTHER ARTISTS OF THE SEVENTEENTH
CENTURY (FIRST HALF)

PERHAPS BY CORNELIUS JOHNSON
(1593–1663/4)
THOMAS, Baron Coventry (1578–
1640). In oil. G 2

BY ALEXANDER COOPER (c.1605–1660)
CHARLES LOUIS, Count Palatine
(1617–1680). A 30
CHARLES LOUIS, Count Palatine
(1617–1680). DSRB 5
This and A 30 are catalogued as by Peter
Oliver, but see above, p. 20.

ATTRIBUTED TO ALEXANDER COOPER
A LADY UNKNOWN. P 14

BY DAVID DES GRANGES (fl. c. 1625–1650)
MARY VILLIERS, Duchess of Rich-
mond and Lenox (1622–1685).
Signed and dated 1648. CC 8

BY WILLIAM FAITHORNE (1616–1691)
BARBARA VILLIERS, Duchess of
Cleveland (1641–1709). N 10
For miniatures attributed to Richard Gibson
(1615–1690), see below, p. 39.

BY ARTISTS UNKNOWN
SIR THOMAS BROWNE (1605–1682).
In oil. DRA 6
SIR DUDLEY CARLETON, Viscount
Dorchester (1573/4–1631/2) ?
In oil. G II
See Cust, Cat. N.P.G, I, 83.
ROBERT CARR, Earl of Somerset,
K.G. (1587–1645) ? B 22
See No. R 12 John Hoskins the elder.
WILLIAM CAVENDISH, Duke of New-
castle, K.G. (1592–1676) ? R 31
See No. DRB 17 by Samuel Cooper.
KING CHARLES I (1600–1649). A 10
Probably SAMUEL DESBOROUGH
(1619–1690), called JOHN DES-
BOROUGH (1608–1680). In oil.
See above, p. 21. O 35

BY ARTISTS UNKNOWN—contd.
Called ANNE, Countess of Derby.

R 32
SIR KENELM DIGBY (1603–1665) ?
In oil. DSRC 6
See No. DRB 34 by Peter Oliver.
Probably WILLIAM DRUMMOND of
Hawthornden. In oil. Dated
1611. G 19
See Caw, Scottish Portraits, II, 28.
THOMAS EGERTON, Baron Elles-
mere (1540 ?–1617) ? DRA 9
See Nos. 416, 422, N.P.E. 1866.
ELIZABETH, Queen of Bohemia
(1596–1662). In oil. D 6
ELIZABETH, Queen of Bohemia
(1596–1662) ? In oil. DSRB 22
See No. D 6 above.
JOHN EVELYN (1620–1706) ? R 19
See No. 1015A, N.P.E. 1866, and Histor.
Portraits 1600–1700, p. 214. Catalogued as
by John Hoskins, but probably not by him.
FREDERICK V, Elector Palatine,
King of Bohemia (1596–1632) ?
In oil. DSRB 17
See No. DSRB 8 by Peter Oliver.
GEORGE GORING, Earl of Norwich
(1583 ?–1662/3) ? BB 7
See Cust, Cat. N.P.G., I, 103; and Century
Mag, XXXVII, 436.
KING JAMES I (1566–1625), QUEEN
ANNE (1574–1619), AND FAMILY
(very much repainted). D 8
CHARLES, Lord Kingston. Q 29
WILLIAM LAUD, Archbishop of
Canterbury (1573–1645). DRB 19
A LADY UNKNOWN, represented as
St. Catherine. A 6
Catalogued as Queen Catherine of Braganza.

COLONEL ROBERT LILBURNE
(1613–1665) ? In oil. R 16
See Propert, History Min. Art, p. 78.

MARGARET LUCAS, Duchess of New-
castle (1617–1673). R 8
See, however, No. 860, N.P.E. 1866.

A MAN UNKNOWN. D 3
A MAN UNKNOWN. B 32
A MAN UNKNOWN. In oil. G 17
A MAN UNKNOWN. In oil. DRB 5
A MAN UNKNOWN, called SIR JOHN
HARINGTON (1561–1612). In oil.
See No. 410, N.P.E. 1866. DSRC 2

A MAN UNKNOWN. In oil. BB 3
A MAN UNKNOWN. In oil. BB 5
Possibly SIR JOSEPH WILLIAMSON, P.R.S.
(1636?–1701).

SIR THEODORE DE MAYERNE (1573–
1655). DRB 33

Called GEORGE MONCK, Duke of
Albemarle, K.G. (1608–1670). P 5
See No. R 6 by Samuel Cooper.

LETTICE MORISON, Lady Falkland
(1612–1646/7). B 9
Signed "I. Z" and catalogued as by Jean
Zurich, a contemporary of C. F. Zincke (MacKay).

SIR SAMUEL MORLAND (1625–
1695). BB 4
See, however, V. & A. M., No. 481—1909.

PENELOPE NAUNTON, Countess of
Pembroke (1620–1647). In oil. N 1

Possibly SIR THOMAS OVERBURY
(1581–1613), called SIR WALTER
RALEIGH (1552?–1618). B 16
See Walpole Soc. Annual, 1913/14, Pl. 39.

SIR ANTHONY SHIRLEY (1565–
1635?) AA 8

Called JOHN THURLOE (1616–
1668). In oil. F 16
See Cust, Cat. N.P.G., I, 121, and No. 812,
N.P.E. 1866.

GEORGE VILLIERS, Duke of Buck-
ingham, K.G. (1592–1628) ? In
oil. Dated 1630. R 2

EDMUND WALLER (1606–1687) ?
BB 1
See Cust, Cat. N.P.G., I, 141 ; and No. 660,
N.P.E. 1866.

THOMAS WENTWORTH, Earl of
Strafford (1593–1641). DRB 13

*PROBABLY AFTER SEVENTEENTH-
CENTURY MINIATURES (c.1600–c 1650)*

Called ARTHUR, Baron Capel of
Hadham (1603/4–1648/9). P 7
See Nos. 741 and 794, N P E. 1866. Pos-
sibly General Charles Fleetwood (d. 1692).
Catalogued as by Peter Oliver, but not by him.

KING CHARLES I (1600–1649). A 5

Called THOMAS, Baron Fairfax
(1612–1671). R 33
See Cust, Cat. N.P.G., I, 115.

Called GEORGE HOWME, Earl of
Dunbar, K.G. (d. 1611/2). DRB 11
See Drummond, Noble Brit Families, II, 2.

Called BENJAMIN JONSON (1573?–
1637). In oil. B 18
Possibly a younger son of Isaac Oliver ;
see above, p. 12.

A LADY UNKNOWN. Q 9

JOHN MILTON (1608–1674), when
young ? F 14

ALGERNON SIDNEY (1622–1683) ?
F 17
See No. F 5 by John Hoskins the younger.

SIR ANTHONY VAN DYCK (1599–
1641). G 1

*POSSIBLY AFTER A PAINTING BY
VAN DYCK (1599–1641)*

A LADY UNKNOWN. K 23
Catalogued as by Peter Oliver, but not by
m.

NICHOLAS DIXON (*fl.* 1667–1708)

Called MARY DAVIS (*fl.* 1663–
1669). N 17
See Cust, Cat. N.P.G., I, 157; and No. R 34.

MARGARET HUGHES (d. 1719). N 13
Catalogued as by Nicholas Dixon, but
perhaps by Paolo Carandini.

Possibly FRANCES JENNINGS, Lady
Hamilton and Duchess of Tyr-
connell (d. 1730/1). Signed. Q 2

A LADY UNKNOWN. Signed. N 3
A LADY UNKNOWN. Signed. N 22
A LADY UNKNOWN. Signed. P 1
A LADY UNKNOWN. P 21
A LADY UNKNOWN. Signed. P 27
A LADY UNKNOWN. Q 17
A MAN UNKNOWN. Signed and
dated 1669. O 6

Louise Renée de Keroualle, Duchess of Portsmouth (1649–1734)? p 15
See Cust, Cat. N.P.G., I, 159; *and* Collins, Baker, Lely and Stuart Portrait Painters, I, 176. Catalogued as by Nicholas Dixon, but perhaps by Paolo Carandini.

Louise Renée de Keroualle, Duchess of Portsmouth (1649–1734)? Signed. p 23
For some other portraits *see* the preceding note. Catalogued as A Lady Unknown, but labelled The Duchess of Portsmouth.

Queen Mary of Modena (1658–1718)? A 29
See Cust, Cat. N.P.G., I, 171, *and* Nos. 1021, 1027, N P E. 1866.

Called Christopher Monck, Duke of Albemarle, K.G. (1653–1688). Signed and dated 1667. p 3
This miniature, representing a man (say) thirty years old, is dated 1667, when Monck was but fourteen.

Called George Monck, Duke of Albemarle, K.G. (1608–1670). Signed. R 39
See No. R 6 by Samuel Cooper.

Prince Rupert, Count Palatine, K.G. (1619–1682)? Signed. A 3
See No. A 31 by Samuel Cooper.

Called James Scott, Duke of Monmouth and Buccleuch, K.G. (1649–1685). Signed. A 7
See No. o 2 by Samuel Cooper.

James Scott, Duke of Monmouth and Buccleuch, K.G. (1649–1685). Signed. p 8

Robert Spencer, Earl of Sunderland, K.G. (1640–1702)? Signed.
See No. 934. N.P.E. 1866. p 13.

PROBABLY BY NICHOLAS DIXON

Countess of Deloraine. p 31

A Lady unknown. N 14

A Lady unknown. N 21

Queen Mary of Modena (1658–1718)? A 21
See Cust, Cat. N.P.G., I, 171, *and* Nos. 1021, 1027, N.P.E. 1866.

Anne Scott, Duchess of Monmouth and Buccleuch (1651–1732). R 27

Lucy Walter (1630?–1658). N 8

ATTRIBUTED TO NICHOLAS DIXON

Called Anna Maria Brudenell, Countess of Shrewsbury (*d.* 1702). p 17
See Cust, Cat. N.P.G., I, 159.

Henry Carey, Earl of Monmouth (1595/6–1661)? AA 3
See Goulding, Cat. Welbeck Abbey Min., Pl. III, No. 14.

Lady Catherine Herbert. Q 26

Mrs. Jane Myddleton (1645–1692)? R 5
See Collins, Baker, Lely and Stuart Portrait Painters, I, 200.

Sir William Temple (1628–1699). p 12
See, however, Cust, Cat. N.P.G., I, 167.

LAWRENCE CROSS (*c.* 1650–1724)

Charles Beauclerk, Duke of St. Albans, K.G. (1670–1726)? Signed. R 35
See Edwards, Photo Histor Portrait Gall., xxxv, iii. The Duke of St. Albans is said to have been much like his father, Charles II; the sitter in the Buccleuch miniature bears no resemblance to him.

Called Godert de Ginkell, Earl of Athlone (1630–1702/3). Signed. p 24
See above, p. 25, *and* No. 1, N.P E. 1867.

John Holles, Duke of Newcastle, K.G. (1661/2–1711), called Henry Fitzroy, Duke of Grafton, K.G. (1663–1690). Signed. R 37
See Goulding, Cat. Welbeck Abbey Min., Pl. xvi, No. 166.

Mary Hyde, Baroness Conway (*d.* 1708/9). Signed. Q 22

Sarah Jennings, Duchess of Marlborough (1660–1744)? Signed. N 11
See Cust, Cat. N.P.G., I, 211.

A Lady unknown. Signed. N 25

A Lady unknown. Signed. Q 21

Called Titus Oates (1649–1705). Signed. p 30
See Cust, Cat. N.P.G, I, 163.

James Scott, Earl of Dalkeith, K.T. (1674–1704/5. Signed. p 11

James Scott, Earl of Dalkeith, K.T. Signed. R 13

SIR EDWARD SPRAGGE (*d.* 1673) ?
Q 12

The style of costume makes this title somewhat doubtful.

AFTER LAWRENCE CROSS

A LADY UNKNOWN. Q 5

JAMES SCOTT, Earl of Dalkeith, K.T. (1674–1704/5). Q 30

Catalogued as CHARLES WILLIAM HENRY, Earl of Dalkeith, by Bernard Lens in error : *see* No. P 11 above.

OTHER ARTISTS OF THE SEVENTEENTH CENTURY (SECOND HALF)

PERHAPS BY EDMUND ASHFIELD
(*fl. c.* 1675–1700)

JOHN MAITLAND, Duke of Lauderdale, K.G. (1616–1682). P 4

BY CHARLES BEALE (*fl. c.* 1660–1689)

Called SAMUEL PEPYS (1633–1703).
Signed and dated 1688. R 22

See S. Pepys Club : Occasional Papers, 1903–1914, p. 36 ; *and cf.* Histor. Portraits, 1600–1700, p. 214.

PERHAPS BY CHARLES BEALE

CAIUS GABRIEL CIBBER (1630–1700). O 17

PERHAPS BY H. BYRNE (*fl. c.* 1650–1675)

A GARTER KNIGHT UNKNOWN. R 7

PERHAPS BY PAOLO CARANDINI
(*fl. c.* 1650–c. 1677)

A CHILD UNKNOWN. Signed and dated 1668. DSRC 4

Nos. N 13, MARGARET HUGHES, and P. 15, the DUCHESS OF PORTSMOUTH (?) are also perhaps by Paolo Carandini.

BY THOMAS FLATMAN (1637–1688)

THOMAS FLATMAN, called SIR HENRY VANE (1613–1662).
Signed and dated 1661. F 12
See above, p. 22.

A MAN UNKNOWN. Signed. F 19

ATTRIBUTED TO THOMAS FLATMAN

GODERT DE GINKELL, Earl of Athlone (1630–1702/3) ? R 26
See No. 1, N.P.E. 1867.

ABRAHAM COWLEY (1618–1667) ?
See Cust, Cat. N P G., I, 143. R 25

PERHAPS BY RICHARD GIBSON (1615–1690)

HENRY CAVENDISH, Earl of Ogle (1663–1680), called JAMES SCOTT, Duke of Monmouth and Buccleuch, K.G. (1649–1685). R 30
See above, p. 21. Catalogued as by Charles Boit but not by him.

ATTRIBUTED TO RICHARD GIBSON

RUPERTA HOWE (*b.* 1673–*c.* 1740).
Q 1

Catalogued as by Richard Gibson, but possibly by Nicholas Dixon.

Called JAMES SCOTT, Duke of Monmouth and Buccleuch, K.G. (1649–1685). P 22
See No. O 2 by Samuel Cooper.

BY DAVID PATON (*fl. c.* 1650–c. 1675).

KING CHARLES II (1630–1685).
Signed and dated 1669. A 9

SIGNED "D.M."

Called HENRY FITZROY, Duke of Grafton, K.G. (1663 – 1690).
Signed and dated 1675/6. BB 6
See above, p. 21.

PERHAPS BY THE ARTIST SIGNING HIMSELF "D.M."

SIR HENRY TERNE (*d.* 1666). Q 6

SIGNED "W. P."

Possibly MARY DAVIS (*fl.* 1663/9), called ELEANOR GWYN (1650–1687).
Signed. R 34
See Cust, Cat N.P.G., I, 157. Catalogued as by William Prewett, but not by him : *see above,* p. 28.

SIGNED "F. S."

ANDREW MARVELL (1621–1678) ?
In oil. Signed. BB 8

See Cust, Cat. P.N G., I, 127, *and* No. 804, N P.E. 1866. Catalogued as by F. Cleyn, *but see* p. 22 above.

A MAN UNKNOWN. In oil. Signed.
DD 5

BY ARTISTS UNKNOWN

QUEEN CATHERINE OF BRAGANZA (1638–1705) ? A 17
See Cust, Cat. N.P.G., I. 137.

KING CHARLES II (1630–1685).
A 13

KING CHARLES II. D 9

JOHN CHURCHILL, Duke of Marlborough, K.G. (1650–1722). O 10

ARTISTS OF THE EIGHTEENTH CENTURY
(FIRST HALF)

BY *BENJAMIN ARLAUD* (fl. 1706–1731)

JOHN CHURCHILL, Duke of Marlborough, K.G. (1650–1722). o 4
Catalogued as by N. DIXON, *but see* p. 26 above.

PRINCE EUGENE OF SAVOY (1663–1736). M 34

PRINCE EUGENE OF SAVOY. J 4

BY *J. A. ARLAUD* (1668–1746)

PRINCE CHARLES EDWARD STUART (1720–1788). L 18

BY *BERNARD LENS* (1682–1740)

ANNA MARIA BRUDENELL, Countess of Shrewsbury (d. 1702).
Q 13

Possibly HENRIETTA CHURCHILL, Countess of Godolphin (1681–1733). Signed and dated 1720.
O 11

MARY CHURCHILL, Duchess of Montagu (1689–1751). Signed. o 38

LORD PERCY SEYMOUR (1686–1721) ? Signed. R 20

Called MARY QUEEN OF SCOTS (1542–1587). Signed and dated 1720. C 17
See above, p. 25.

PERHAPS BY *BERNARD LENS*

MARY CHURCHILL, Duchess of Montagu (1689–1751). R 14

KING GEORGE I (1660–1727). L 12

CATHERINE SHORTER, Lady Walpole (1682–1737). o 27
Catalogued as by C. F. Zincke, but probably by Bernard Lens.

ISABELLA MONTAGU, Duchess of Manchester (d. 1786). o 32

IN THE *STYLE OF BERNARD LENS*

ELIZABETH CHURCHILL, Countess of Bridgewater (1687/8–1713/4), and ANNE CHURCHILL, Countess of Sunderland (1682/3–1716).
O 39

BY *ANDREW BENJAMIN LENS* (fl. 1765–1770)

ALEXANDER POPE (1688–1744). Signed. Q 27
Catalogued as by Bernard Lens in error.

BY *CHRISTIAN RICHTER* (c.1682–1732)

JOHN CHURCHILL, Duke of Marlborough, K.G. (1650–1722). Signed and dated 1714. o 19

PERHAPS BY *CHRISTIAN RICHTER*

OLIVER CROMWELL (1599–1658).
F 8

MATTHEW PRIOR (1664–1721).
Q 15
Catalogued as by Bernard Lens, but perhaps by Christian Richter : *see above*, p. 26.

BY *F. STOGLO*

JAMES BUTLER, Duke of Ormonde, K.G. (1610–1688) ? Signed and dated 1718. o 21
See Histor. Portraits 1600–1700, p. 196.

PERHAPS BY *SIR ROBERT STRANGE* (1721–1792)

PRINCE JAMES FRANCIS EDWARD STUART (1688–1766). Signed.
L 23

BY *ARTISTS UNKNOWN*

A BOY UNKNOWN. BB 11

ELIZABETH CHURCHILL, Countess of Bridgewater (1688–1713/4).
O 24

KING GEORGE I (1660–1727). L 10

KING GEORGE I (1660–1727). L 14

A LADY UNKNOWN. P 29

JOHN BRUDENELL-MONTAGU, Marquess of Monthermer (1734/5–1770). H 24

HENRY ST. JOHN, Viscount Bolingbroke (1678–1751) ? o 14
See No. 109, N.P.E. 1867 ; *and* Histor. Portraits 1600–1700, p. 282.

PRINCE HENRY BENEDICT STUART (1725–1807). BB 10

PRINCE JAMES FRANCIS EDWARD STUART (1688–1766). In oil.
L 15

JONATHAN SWIFT, D.D. (1667–1745). In oil. o 43

HORACE WALPOLE, Earl of Orford (1717–1797). BB 12

ARTISTS OF THE EIGHTEENTH CENTURY
(SECOND HALF)

PERHAPS BY *FRANÇOIS ARTAUT*
(1767–1838)

KING JAMES II (1633–1701). L 11
Catalogued as by J. A. Arlaud, *but see*
p. 26 above.

BY *RICHARD COLLINS* (1755–1831)

PRINCESS AUGUSTA SOPHIA (1768–
1840), called PRINCESS AMELIA
(1783–1810). H 18
See Williamson, Cat. Coll. Min. *House of
Brunswick*, pl. 22–24 and 32.

BY *PENELOPE COTES* (*fl. c.* 1750–1775)

A BOY UNKNOWN. Signed. Q 28

BY *SYLVESTER HARDING* (1745–1809)

Called MARY QUEEN OF SCOTS
(1542–1587). Signed. C 22
See Burlington Magazine, IX, 26. Possibly
Catherine Carey, Countess of Nottingham.

BY *OZIAS HUMPHRY, R A.* (1742–1810)

MARY PANTON, Duchess of An-
caster (1730–1793) ? Signed
and dated 1770. H 23
See above, p. 26.

BY *SAMUEL SHELLEY* (*c.* 1750–1808)

A LADY UNKNOWN. CC 13

BY *GERVASE SPENCER* (d. 1763)

A LADY UNKNOWN. Signed. H 9

BY *P. E. STROEHLING* (*fl. c.* 1800–c. 1825)

PRINCESS CHARLOTTE AUGUSTA
MATILDA (1766–1828). H 5

BY *ARTISTS UNKNOWN*

SIR RALPH ABERCROMBY (1734–
1801). H 8

EDMUND BURKE (1729–1797). In
oil. H 12

QUEEN CHARLOTTE SOPHIA (1744–
1818). H 4

DAVID GARRICK (1717–1779). H 16

WARREN HASTINGS (1732–1818).
BB 16

A LADY UNKNOWN. Q 14

A LADY UNKNOWN. CC 9
Catalogued as by Richard Cosway, R.A.,
but not by him.

WILLIAM PITT (1759–1806). H 1

MARGARET GEORGIANA POYNTZ,
Countess Spencer (1737–1814).
CC 10
Catalogued as by C. F. Zincke, but not
by him.

PRINCE HENRY BENEDICT STUART
(1725–1807). L 24

BY *ARTISTS UNKNOWN OF THE NINE-
TEENTH CENTURY*

A BOY UNKNOWN, called P. B.
SHELLEY (1792–1822). E 4
See Cust, Cat. N P.G , II, 141.

OLIVER CROMWELL (1599–1658)
and JOHN MILTON (1608–1674).
F 18

A MAN UNKNOWN. E 10

ENAMELS

PERHAPS BY RUPERT BARBER
(*fl.* 1736–1772)

JONATHAN SWIFT, D.D. (1667–
1745). O 40
Catalogued as by F. Bindon, but more
probably after a painting by him.

BY *CHARLES BOIT* (1663–1727)

QUEEN ANNE (1665–1714). Signed
and dated 1713. L 6

JAMES BUTLER, Duke of Ormonde,
K.G. (1665–1745) ? O 37
See Cust, Cat. N.P.G., I, 207, *and* No. 26,
N.P.E. 1867.

BY *CHARLES BOIT—contd.*

ADMIRAL GEORGE CHURCHILL
(1654–1710). Signed. O 22

PETER THE GREAT (1672–1725).
Signed. DSRB 9

GENERAL MICHAEL RICHARDS
(1673–1721) O 7

PERHAPS BY CHARLES BOIT

JAMES SCOTT, Duke of Monmouth
and Buccleuch, K.G. (1649–
1685). R 10

42

BY *HENRY PIERCE BONE* (1779-1855)
John Churchill, Duke of Marl-
borough, K.G. (1650 – 1722).
Signed and dated 1795. o 16
Arthur Wellesley, Duke of Wel-
lington, K.G. (1769 – 1852).
Signed and dated 1840. H 10

BY *WILLEM DE KEYSER* (*c.* 1647-*c.* 1692)
King James II (1633–1701). A 33

BY *JOSEPH LEE* (1780-1859)
Princess Charlotte Augusta of
Wales (1796–1817). Signed. H 3
Catalogued as by Henry Spicer (d. 1804)
in error.

BY *JEREMIAH MEYER, R.A.* (1735–1789).
Benjamin Franklin (1706–1790).
Signed. BB 18

BY *WILLIAM PREWETT* (*fl. c.* 1725-1750)
Horace Walpole, Earl of Orford
(1717–1797). Signed and dated
1735. o 31

SIGNED *"W. P."*
George Washington (1732–
1799). Signed. H 13
Catalogued as by William Prewett, but
probably not by him : *see above,* p. 29.

BY *JEAN ANDRE ROUQUET* (1702-1759)
A Lady unknown. H 14

BY *GERVASE SPENCER* (d. 1763)
Admiral John Byng (1704–
1757) ? Signed and dated 1752.
See No. 805, N.P.E. 1868. H 17

BY *CHRISTIAN FRIEDRICH ZINCKE*
(*c.* 1684-1767)
Queen Anne (1665–1714). Signed.
L 2
Called Queen Anne (1665–1714).
Signed and dated 1715. L 13
George Brudenell, Earl of Car-
digan and Duke of Montagu,
K.G. (1712–1790). o 33
James Brydges, Duke of Chandos
(1672/3-1744). Signed. o 15
Jenny Cameron of Lochiel (*fl.
c.* 1745). H 19
Probably Anne Churchill, Coun-
tess of Sunderland (1682/3–1716)
Cf. Cust, Cat. N.P.G., I, 211. o 18

CHRISTIAN FRIEDRICH ZINCKE—contd.
Elizabeth Churchill, Countess
of Bridgewater (1687/8–1713/4).
o 5
Possibly Henrietta Churchill,
Countess of Godolphin (1681–
1733). o 20
Possibly Henrietta Churchill,
Countess of Godolphin. o 28
Possibly Henrietta Churchill,
Countess of Godolphin. o 30
With o 20, 28, and 30, *cf.* o 11 above, by
Bernard Lens.
Mary Churchill, Duchess of Mon-
tagu (1689–1751). o 41
Richard Grenville, Earl Tem-
ple, K.G. (1711–1779). o 36
George Frederick Handel
(1685–1759) ? H 11
See Cust. Cat. N.P.G., I, 239, *and* No. 411
N.P.E. 1867; *and cf.* No. H 7 below.
Catherine Hyde, Duchess of
Queensberry (*c.*1701–1777). o 13
A Lady unknown. o 42
A Man unknown. H 2
A Man unknown. H 6
Isabella Montagu, Duchess of
Manchester (*d.* 1786). o 9
John, Duke of Montagu, K.G.
(1689–1749). o 1
Henry Sacheverell, D.D.
(1674 ?–1724) ? R 28
See Cat. Oxford Loan Exhibition, 1906,
pl. ii, No. 28.
Sir Robert Walpole, Earl of
Orford, K.G. (1676–1744/5).
o 25
Edward Young, D.C.L. (1683–
1765) ? H 22
See Cat. Oxford Loan Exhibition, 1906,
pl. vi, No. 77.

ATTRIBUTED TO C. F. ZINCKE
Queen Mary II (1662–1694) ? L 5
See Cust. Cat. N.P.G., I, 187, *and* William-
son, History Portrait Min., I, xlvii, 5.
Princes Charles Edward Stuart
(1720–1788) and Henry Bene-
dict Stuart (1725–1807). L 16
Catalogued as by Zincke, but probably by
a French enamellist.

CPSIA information can be obtained
at www.ICGtesting.com
Printed in the USA
BVHW041214241118
533619BV00032B/731/P